MIDLOTHIAN
PUBLIC LIBRARY

AMERICAN IMPRESSIONISM

AMERICAN IMPRESSIONISM

Treasures from the
Smithsonian American Art Museum

Elizabeth Prelinger

Watson-Guptill Publications/New York

Smithsonian American Art Museum

American Impressionism: Treasures from the
Smithsonian American Art Museum

By Elizabeth Prelinger

Chief, Publications: Theresa Slowik
Designers: Steve Bell, Robert Killian
Editorial Assistant: Tami Levin

Library of Congress Cataloging-in-Publication Data

National Museum of American Art (U.S.)
 American impressionism : treasures from the
Smithsonian American Art Museum /
Elizabeth Prelinger.
 p. cm.
Includes index.
 ISBN 0-8230-0190-3
 1. Impressionism (Art)—United States—Exhibitions.
2. Painting, American—Exhibitions. 3. Paintings,
Modern—19th century—United States—Exhibi-
tions. 4. Painting, Modern—20th century—United
States—Exhibitions. 5. National Museum of Ameri-
can Art (U.S.)—Exhibitions. I. Prelinger, Elizabeth.
II. Title.
 ND210.5.14 N38 2000
 759.13'09'03407473—dc21
 99-050578

Printed and bound in Italy

First printing, 2000
1 2 3 4 5 6 7 8 9 / 07 06 05 04 03 02 01 00

© 2000 Smithsonian Institution
First published in 2000 by Watson-Guptill Publica-
tions, a division of BPI Communications, 1515
Broadway, New York, NY 10036, in association
with the Smithsonian American Art Museum.

Cover: Childe Hassam, *The South Ledges, Appledore*
(detail), 1913, oil. Smithsonian American Art Mu-
seum, Gift of John Gellatly (see page 54).

Frontispiece: Maria Oakey Dewing, *Garden in May*
(detail), 1895, oil. Smithsonian American Art
Museum, Gift of John Gellatly (see page 26).

American Impressionism is one of eight exhibitions in *Treasures to Go*, from the Smithsonian American Art Museum, touring the nation through 2002. The Principal Financial Group® is a proud partner in presenting these treasures to the American people.

Foreword

Museums satisfy a yearning felt by many people to enjoy the pleasure provided by great art. For Americans, the paintings and sculptures of our nation's artists hold additional appeal, for they tell us about our country and ourselves. Art can be a window to nature, history, philosophy, and imagination.

The collections of the Smithsonian American Art Museum, more than one hundred seventy years in the making, grew along with the country itself. The story of our country is encoded in the marvelous artworks we hold in trust for the American people.

Each year more than half a million people come to our home in the historic Old Patent Office Building in Washington, D.C., to see great masterpieces. I learned with mixed feelings that this neoclassical landmark was slated for renovations. Cheered at the thought of restoring our magnificent showcase, I felt quite a different emotion on realizing that this would require the museum to close for three years.

Our talented curators quickly saw a silver lining in the chance to share our greatest, rarely loaned treasures with museums nationwide. I wish to thank the dedicated staff who have worked so hard to make this dream possible. It is no small feat to schedule eight simultaneous exhibitions and manage safe travel for more than five hundred precious artworks for more than three years, as in this *Treasures to Go* tour. We are indebted to the dozens of museums around the nation, too many to name in this space, that are hosting the traveling exhibitions.

The Principal Financial Group® is immeasurably enhancing our endeavor through its support of a host of initiatives to increase national awareness of the *Treasures to Go* tour so more Americans than ever can enjoy their heritage.

American Impressionism, written by Dr. Elizabeth Prelinger, celebrates a style that has enjoyed immense popularity among artists, the public, and collectors since the late nineteenth century. Luminous landscapes, domestic scenes, and figure studies reveal an experimentation with vibrant light and color that infused American art with new vitality. Painting outdoors to capture changing effects of light and shadow or working in their studios from sketches made on site, the impressionists laid the groundwork for much avant-garde painting that followed.

Individual artists developed distinctive interpretations and styles. Associated with the French impressionists during his early days in Paris, James McNeill Whistler experimented with landscapes that dissolve into veils of color. Mary Cassatt, Childe Hassam, John Twachtman, Thomas Wilmer Dewing, and William Merritt Chase relished the possibilities of a palette that ranged from the ethereal to the intensely bright. Maurice Prendergast, Henry Ossawa Tanner, Arthur Wesley Dow, and Daniel Garber took this revolutionary style in fresh, more modern, directions.

The Smithsonian American Art Museum is planning for a brilliant future in the new century. Our galleries will be expanded so that more art than ever will be on view, and in an adjacent building, we are opening a new American Art Center—a unique resource for information on America's art and artists, staffed for public use. We are also planning new exhibitions, sponsoring research, and creating educational activities to celebrate American art and understand our country's story better.

Elizabeth Broun
Director
Smithsonian American Art Museum

JOHN WHITE ALEXANDER

1856–1915

June

about 1911, oil
124.3 x 91.6 cm
Smithsonian
American Art
Museum, Gift of
William Alexander

John White Alexander, who was born near Pittsburgh but spent many years in Europe, specialized in decorative, lyrical images of women that are not necessarily portraits. Here, the title *June* may refer to the unidentified model, or it may suggest an allegorical scene of the early summer month. The painting's subtitle, "A Flower," could refer both to the beautiful young woman and to the blossom in the vase she holds. Like many turn-of-the-century artists, Alexander sometimes chose subjects drawn from such literary sources as the English poet John Keats and the Italian poet Giovanni Boccaccio.

Although *June* has no discernible narrative, the scene is suffused with a sense of mystery through its shadowy illumination, its evocation of the flower's fragrance, and its symbolic title. The brushy handling of paint relates Alexander's work to impressionism, while his gift for bold patterning as a compositional device emerges in the dramatic juxtaposition of the contrasting vertical stripes at the right edge of the painting.

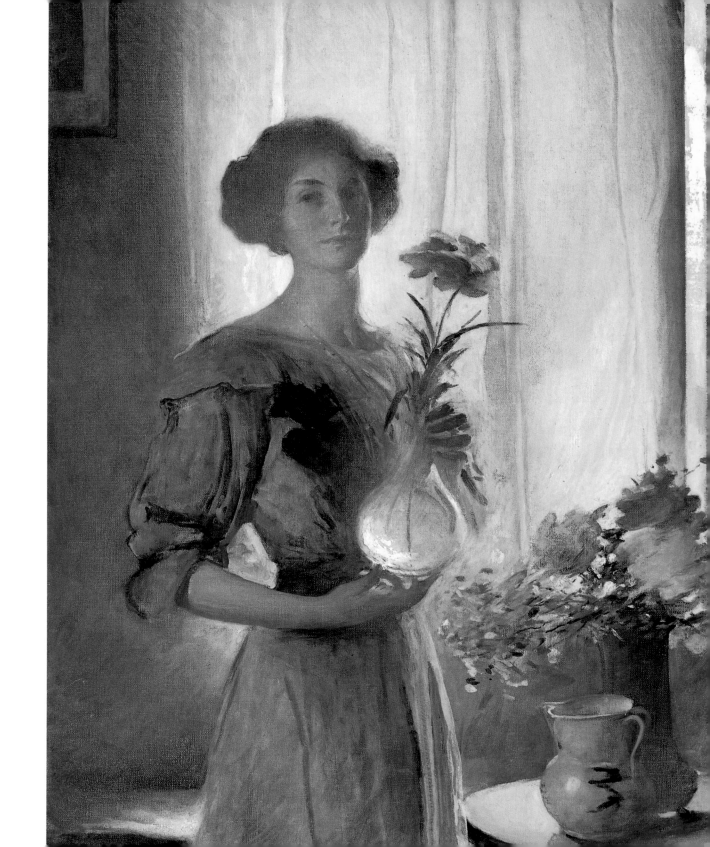

JOHN WHITE ALEXANDER

1856–1915

Landscape, Cornish, New Hampshire

about 1890, oil
77.2 x 114.2 cm
Smithsonian
American Art
Museum

In this pure landscape, Alexander directs our eyes up toward rolling hills and grazing sheep to the trees and clouds. The lack of detail allows us to concentrate on the flowing, harmonious relationship of earth and sky. Alexander brushed his paint on thinly, leaving the large weave of the canvas support visible throughout except in the center, where a few green accents hover on the surface of the painting. The picture's lyrical vision suggests that the scene is as much an expressive interpretation of the artist's intimate connection to the land as it is a record of the site.

Best known for his decorative images of women, Alexander enjoyed recognition for his mural decorations for the Library of Congress, in Washington, D.C. The artist also painted scenes around Cornish, New Hampshire, home to him and to other painters including Maria Oakey Dewing and her husband, Thomas Wilmer Dewing.

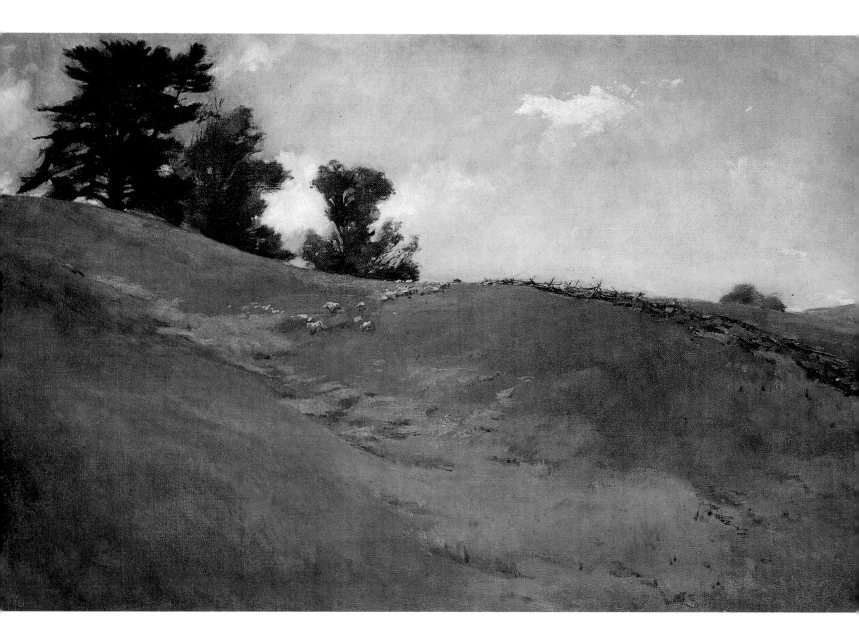

FRANK W. BENSON

1862–1951

Still Life

about 1926, oil
114.9 x 153.4 cm
Smithsonian
American Art
Museum, Bequest of
Henry Ward Ranger
through the National
Academy of Design

Benson painted many sunstruck landscapes and figural scenes, but *Still Life* is an unusually large and formal work. Although the informal paint handling relates it to the impressionists, its monumental size, composition, and muted colors recall the grandeur of old-master paintings.

An interesting story lies behind this work. Scholars knew Benson had painted a similar image, called simply *Interior*. That still life had disappeared and was known only through an old photograph. It was then discovered that, not satisfied with *Interior*, Benson painted over that canvas to create *Still Life*. By adding the vase of flowers, fan, necklace, and stand from which the exotic bird surveys the scene, the artist transformed his picture into a more complex arrangement, with the feminine ornaments lending a touch of mystery to the shadowy assemblage of elegant objects.

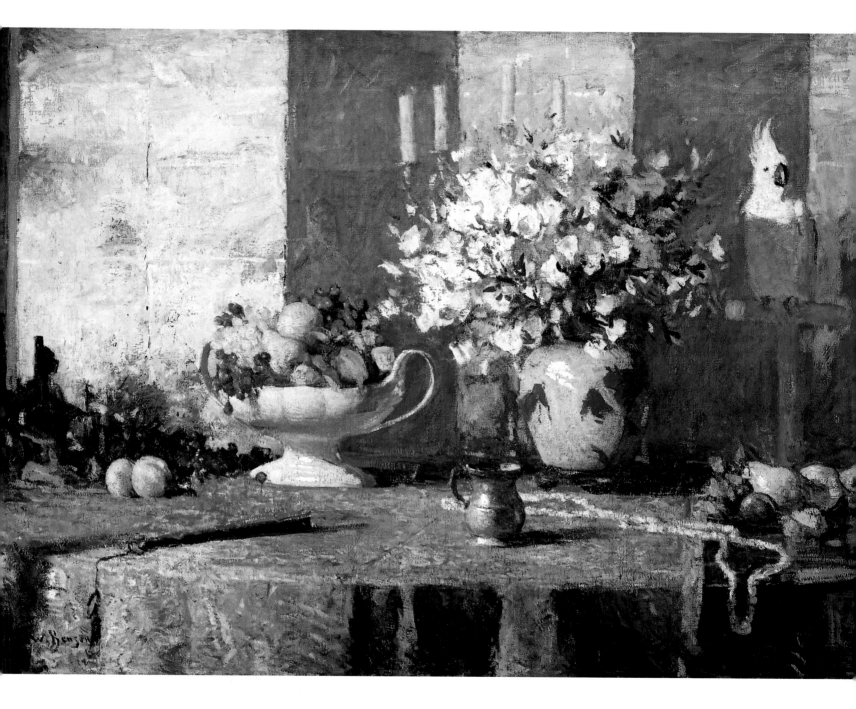

ROBERT FREDERICK BLUM

1857–1903

Canal in Venice, San Trovaso Quarter

about 1885, oil
86.5 x 58.6 cm
Smithsonian
American Art
Museum, Gift of
William T. Evans

From about 1860 to 1920, Venice was the favorite city of many American artists including Whistler, Chase, and Sargent, as well as literary figures such as Henry James. Considered one of the world's most picturesque places, the nexus of East and West, Venice was sought after by painters of all nationalities who wished to capture its special magic.

For this picture, made during one of his numerous Venice sojourns, Blum chose a scene from the Rio Ogni Santi, in the San Trovaso quarter. The vertical format emphasizes our sense of being in a boat on the canal. Ahead, a man poles a gondola, or perhaps a smaller craft called a *sandolo*. As with many artists who depicted Venetian subjects, Blum wanted to capture the allure of the city's light reflected in the elusive quality of the water, buildings, and bridges; to heighten the textures of these elements, the artist left portions of the canvas bare. Blum's artist colleagues so appreciated his eloquent views of Venice that they often purchased his works, including *Canal in Venice*.

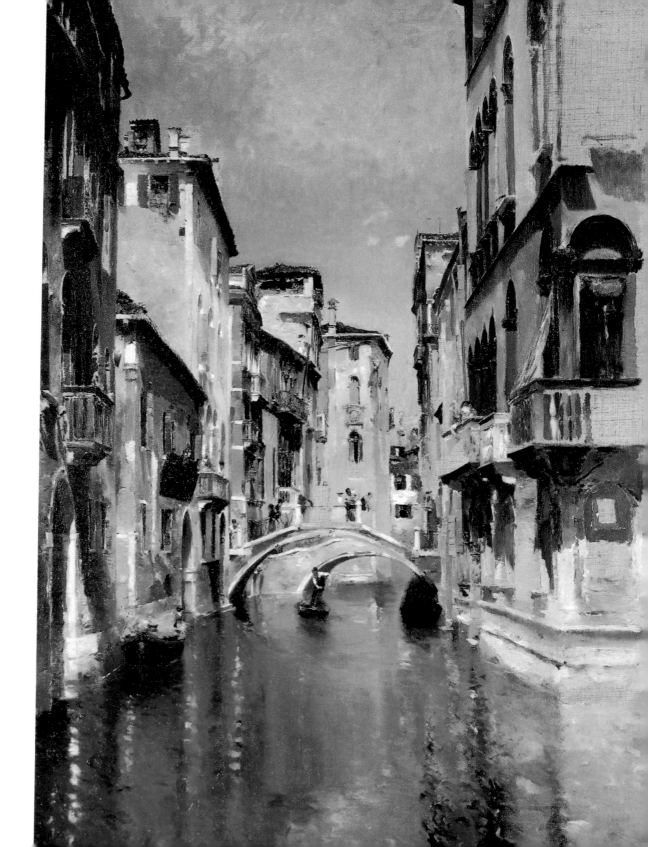

EMIL CARLSEN

1853–1932

The South Strand

about 1909, oil
101.5 x 114.2 cm
Smithsonian
American Art
Museum, Gift of
William T. Evans

The South Strand illustrates Carlsen's poetic approach to nature. On a magnificent day, an empty boat waits on the shore while distant fishermen prepare to set out. The immense sky, embellished with billowing clouds, meets the tranquil sea at the horizon. This atmospheric image reveals Carlsen's philosophical, even religious, temperament, his gift for cherishing the subtle splendor of a simple moment.

The Danish-born Carlsen specialized in still-life painting in the manner of the eighteenth-century French artist Jean-Baptiste Chardin, whose work he studied in Paris in the 1880s. At the turn of the century, he began exploring the effects of light and the multifarious forms of nature using a soothing palette of beiges and silvery grays. During his second Paris sojourn, from 1884 to 1886, Carlsen studied the techniques of French impressionists Claude Monet and Auguste Renoir, adopting some of their freshness and spontaneity.

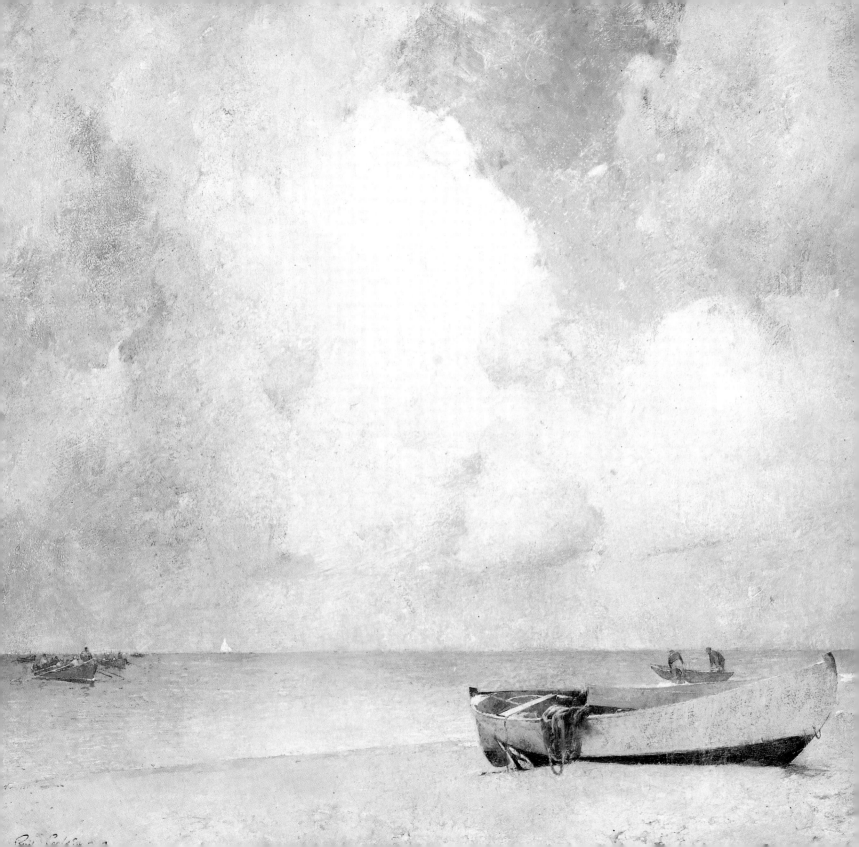

MARY CASSATT

1844–1926

The Caress

1902, oil
83.4 x 69.4 cm
Smithsonian
American Art
Museum, Gift of
William T. Evans

The Caress is neither a portrait of family members nor a commission by clients, but rather a studio composition painted from professional models. Perhaps this permitted the artist to emphasize the unusual color scheme of green and mauve and the abstract patterns formed by the figures and chair in the stark room rather than psychological intimacy. The mother's right arm seems more important to the pattern of curves in the overall composition than to a sense of protectiveness.

The scene is not without larger meaning; it recalls numerous Renaissance paintings of the Madonna and Christ child with John the Baptist that were influential on Cassatt. Critics praised *The Caress,* which won two important prizes in Philadelphia and Chicago before being presented to the Smithsonian American Art Museum in 1911.

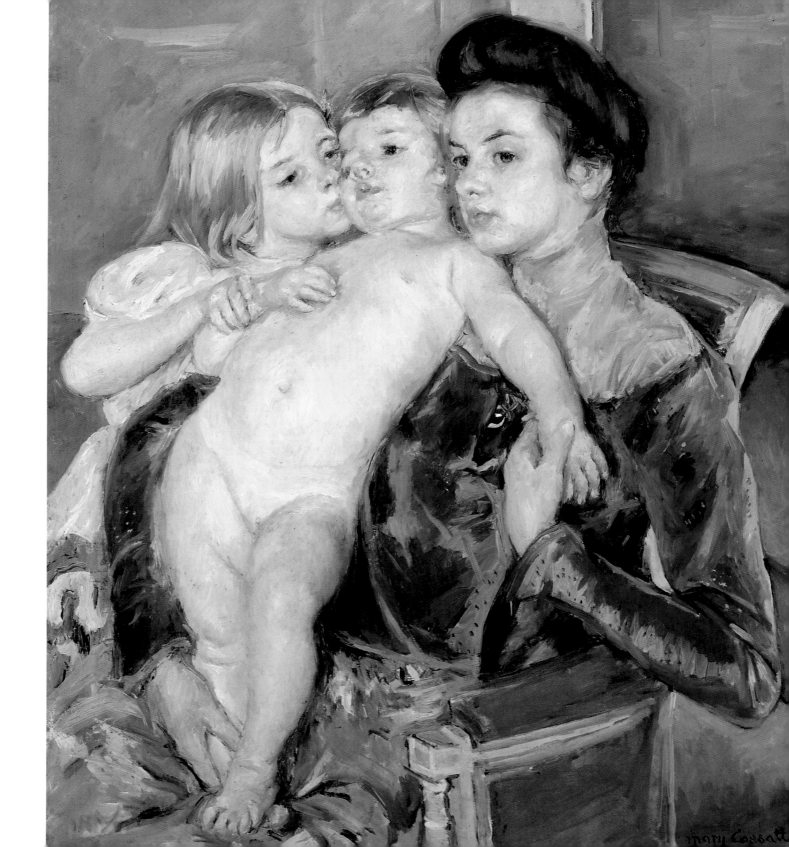

MARY CASSATT

1844–1926

Spanish Dancer Wearing a Lace Mantilla

1873, oil

65.2 x 50.1 cm

Smithsonian

American Art

Museum, Gift of

Victoria Dreyfus

Philadelphia painter Mary Cassatt spent most of her life in Paris, where she was a close friend and colleague of the French impressionists, especially Edgar Degas. During the Franco-Prussian War (1870–71), she left Paris and traveled to Italy and Spain. In 1872, Cassatt set up a studio in Seville, where she painted *Spanish Dancer*.

The work is stylistically related to such seventeenth-century Spanish masters as Diego Velázquez, whose work also influenced the impressionist Edouard Manet during the 1860s. In this introspective and informal portrait, Cassatt drew upon the Spanish tradition of contrasting light and dark areas for dramatic impact. Her bold, expressive strokes vividly render the embroidered veil, which stands out so effectively against the unelaborated setting.

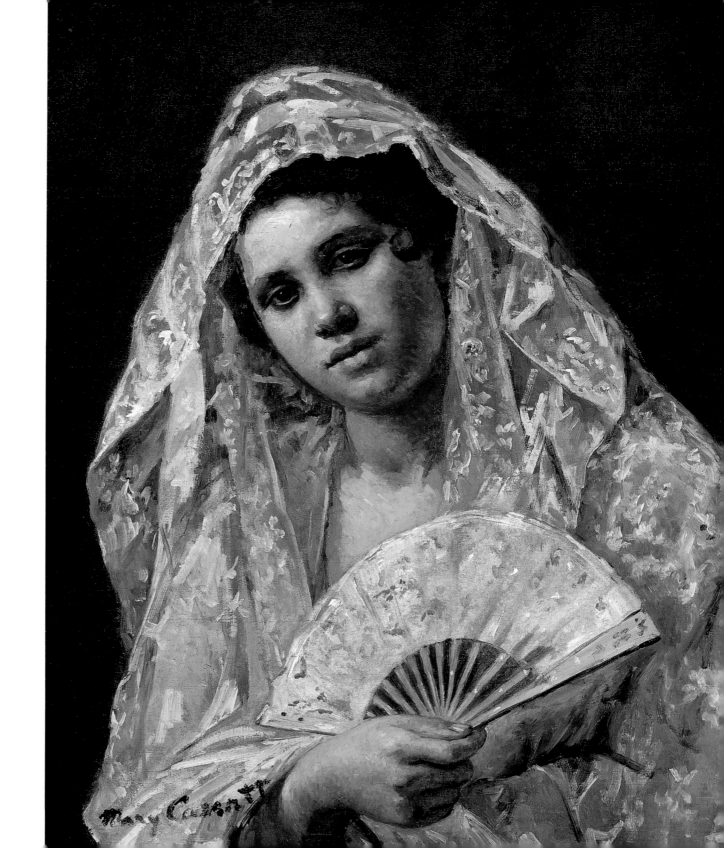

WILLIAM MERRITT CHASE

1849–1916

Girl in White

about 1890, oil
77.8 x 64.7 cm
Smithsonian
American Art
Museum, Gift of
Mrs. Howard
Weingrow

Chase was as well known for his remarkable New York City studio, filled with exotic objects, as he was for his insightful portraits and vivid landscape paintings. Unlike his landscapes, which are painted in a light-filled, impressionistic style, Chase's portraits, including *Girl in White,* are indebted to the dark, highly contrasting, loosely brushed technique the artist learned in Munich, where he studied during the 1870s.

We do not know who the model was for this work, nor is it clear whether the painting is finished. What is obvious is Chase's bravura brush handling. A few brilliant strokes bring to life the filmy white gown, resplendent against the dark background. *Girl in White* reveals the artist's ability to penetrate the character and psychology of his sitters (seen here in the model's serious expression and steady gaze) as well as to capture the tactile quality of textures.

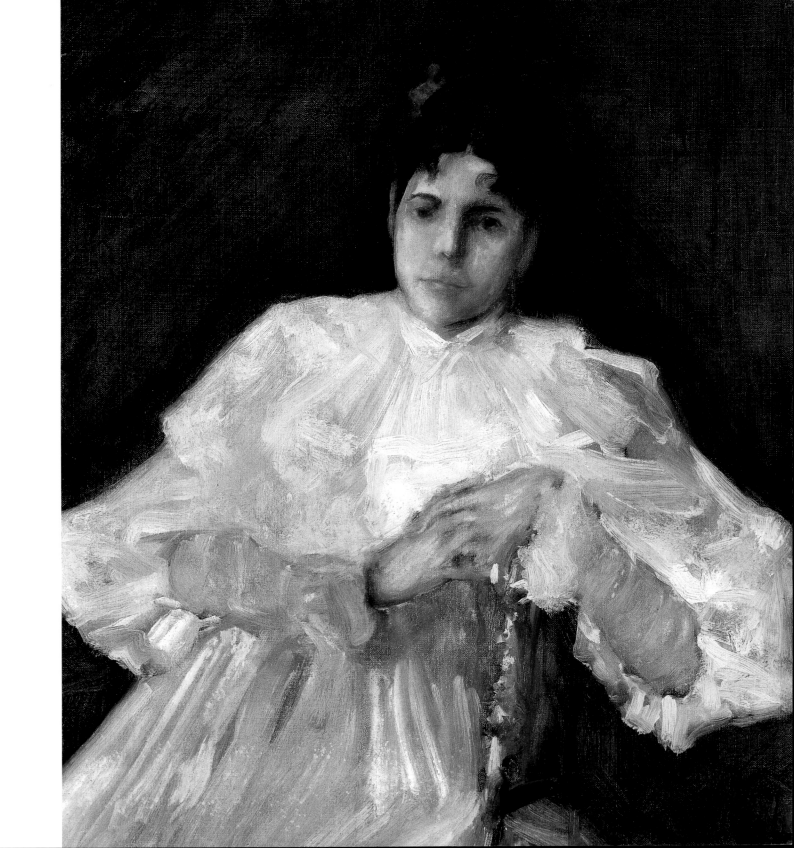

WILLIAM MERRITT CHASE
1849–1916

Shinnecock Hills

(detail)
about 1895, oil
86.6 x 100.4 cm
Smithsonian
American Art
Museum, Gift of
William T. Evans

An accomplished painter, Chase was also an outstanding teacher. He had received formal training at the National Academy of Design in New York City and at the Royal Academy in Munich. From 1891 to 1902, he taught at the summer art school in Shinnecock, on eastern Long Island, where he promoted the plein air method of landscape painting.

Shinnecock Hills embodies Chase's talent for capturing the transient effects of nature and light with extraordinary freshness, as he said, "right under the sky." Chase used his favorite compositional device, a winding road that leads toward the horizon across low, rolling hills. The expansive sky and fluffy clouds embrace the green earth, conveying the artist's personal joy in the simple Long Island setting where he, his family, and his pupils passed many happy and productive years.

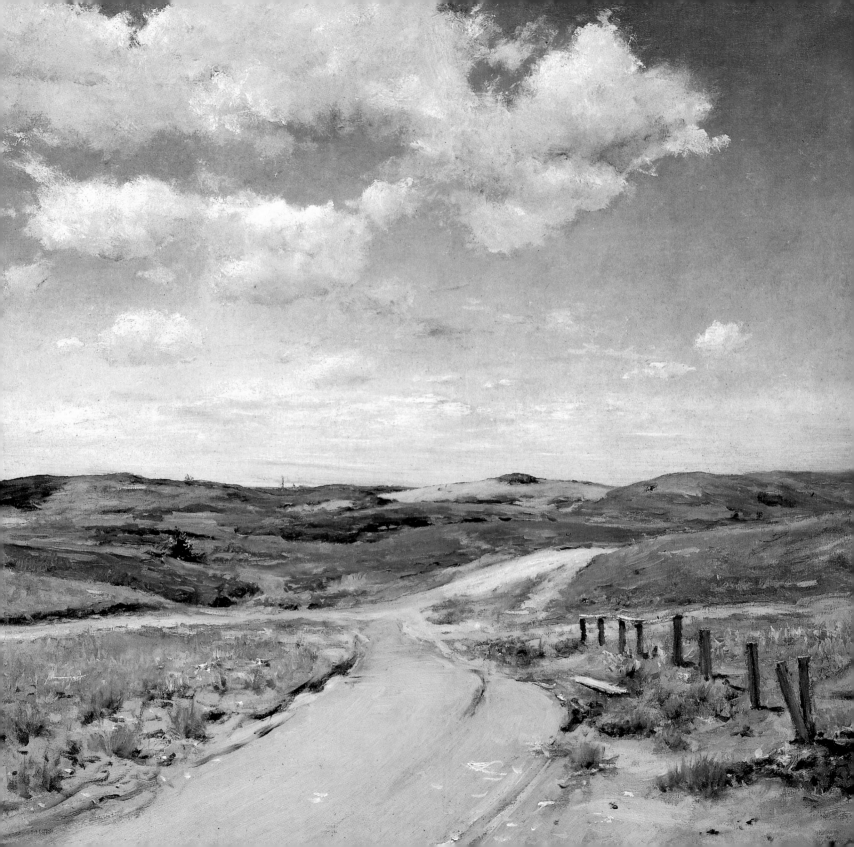

MARIA OAKEY DEWING

1845–1927

Garden in May

1895, oil
60.1 x 82.5 cm
Smithsonian
American Art
Museum, Gift of
John Gellatly

Royal Cortissoz, a famous early-twentieth-century critic, greatly admired Dewing's exquisite *Garden in May* when it was borrowed for exhibition in 1923. He described its "beauty of design . . . its delicacy in the detachment of white and pink blossoms against a background of heavenly green, and its distinguished style. It is painted in a singularly reticent and haunting key."

In spite of Cortissoz's praise, the public reportedly did not like Dewing's picture of her treasured New Hampshire garden. Its close-up view of nature's wildly luxuriant tangle, a departure from the more traditional interior setting of vase and table, may have confused, even disturbed, viewers. Should a woman paint something so seemingly uncontrolled? At the time, this unconventional vision seemed threatening, unlike the romantic scenes of elegant, idealized women painted by Dewing's husband, Thomas Wilmer Dewing.

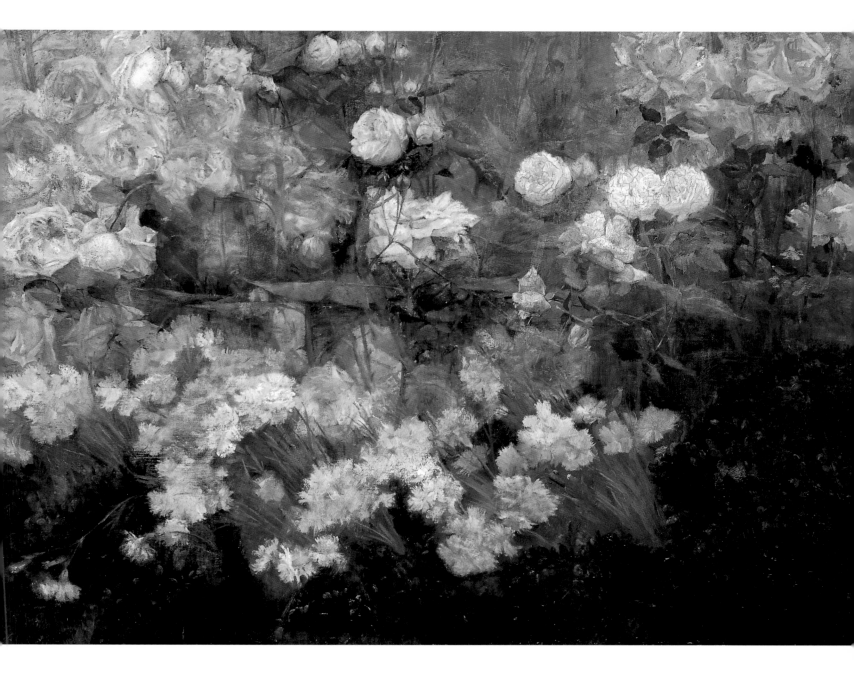

THOMAS WILMER DEWING

1851–1938

The Hermit Thrush

1890, oil

88.1 x 117 cm

Smithsonian
American Art
Museum, Gift of
John Gellatly

The Hermit Thrush "fairly thrills with music," enthused the art critic Royal Cortissoz in 1895. Thomas Dewing was indeed a master at evoking many senses in his softly focused images of beautiful women in mysterious landscapes. Working in Cornish, New Hampshire, in a colony of artist friends, Dewing kept a lookout for potential models, either within the community or visiting from such cities as Boston. In this picture, two of his characteristically elegant women stand amid tall grasses, transfixed by the song of the hermit thrush, "the last to sing in the evening and the first in the morning." The serpentine curves of the pine branches at upper left create a sense of equivalence to the punctuated calls of the bird, which we are given to imagine through the picture's swirling forms and misty colors. Dewing's painting is symbolist, suggestive of feelings, senses, and ideas, rather than descriptive or narrative. Dewing rendered mood with unusual tones and hues; his pictures possess a soothing and elusive magic.

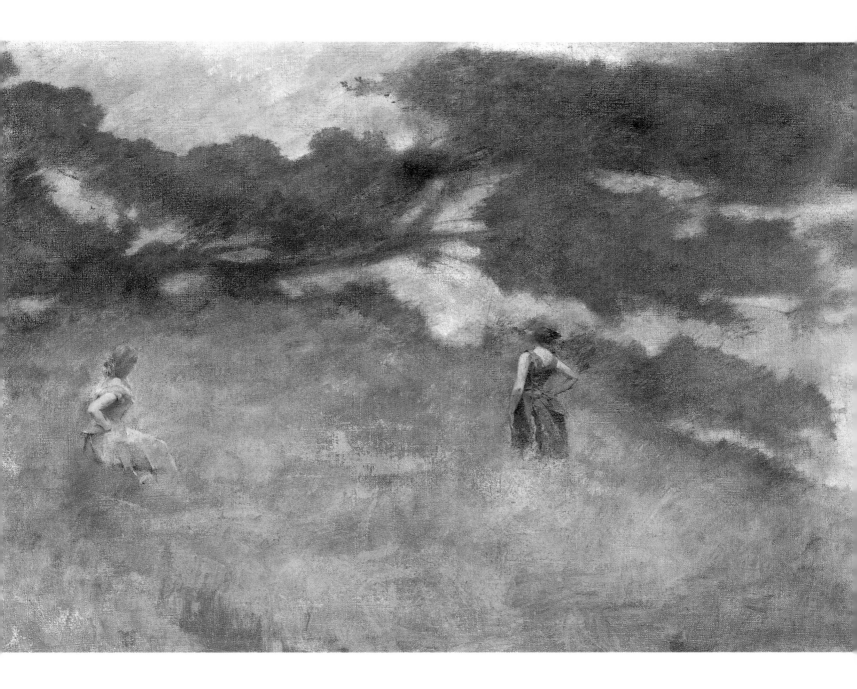

THOMAS WILMER DEWING

1851–1938

Lady in White (No. 1)

about 1910, oil
66.6 x 51.3 cm
Smithsonian
American Art
Museum, Gift of
John Gellatly

Lady in White (No. 1) mesmerizes, disturbs. Dewing's woman sits as if in a trance, positioned in front of a cheval mirror that, chillingly, offers no reflection. To enhance the image's troubling atmosphere, the artist worked with a limited range of white, yellow, and gray tones, compensating for the austere setting by bravura handling of the folds of her billowing dress, which catch the light in varying ways. Critics of the time remarked on the picture's resemblance to James McNeill Whistler's *Portrait of the Artist's Mother*, both in its color and composition.

Considered in context, this painting is even more ambiguous, perhaps even subtly polemical. By 1910, modernist art trends such as cubism and expressionism had become well known. Dewing never embraced the new styles, resolutely adhering to the "well-bred" figure painting characteristic of much fin de siècle art. Was it a compliment when a contemporary of the artist observed of *Lady in White (No. 1)* that the canvas "stands a little apart as if turning to the demure restraint of the past century, and a little skeptical of the brilliant color, dancing sunshine, and aggressiveness of things modern"?

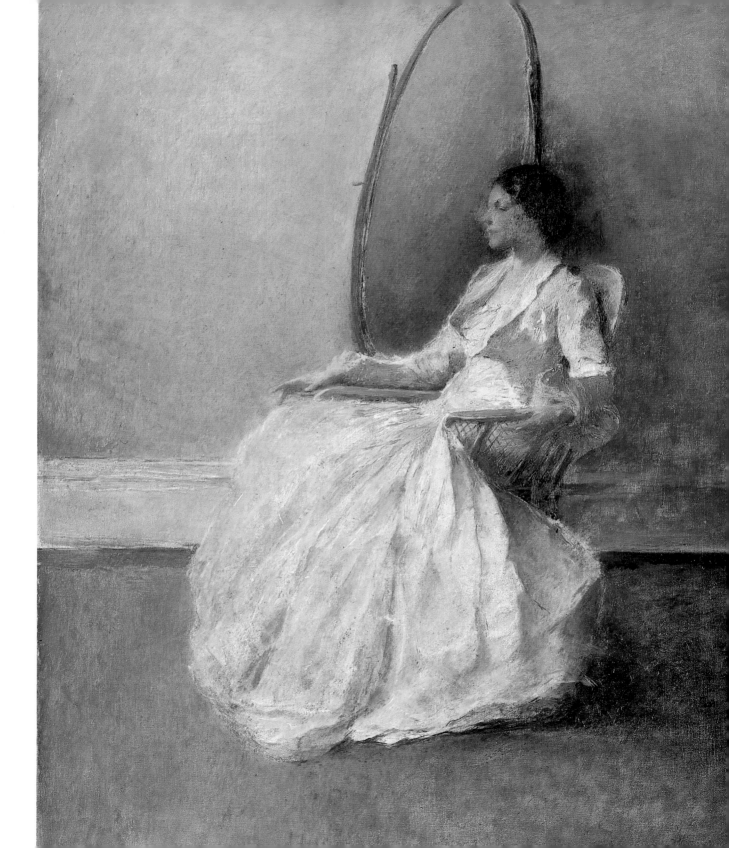

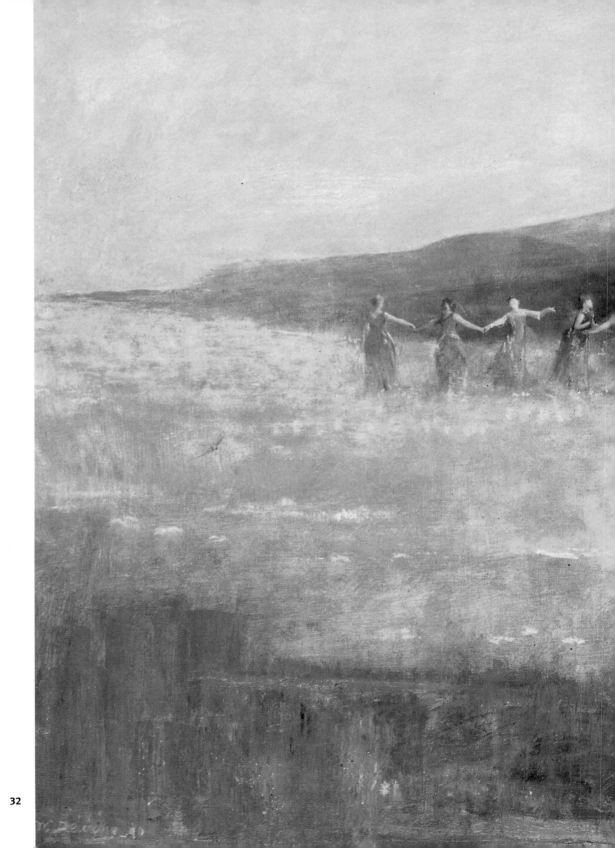

THOMAS WILMER DEWING

1851–1938

Spring

1890, oil
52.1 x 87.9 cm
Smithsonian
American Art
Museum, Gift of
John Gellatly

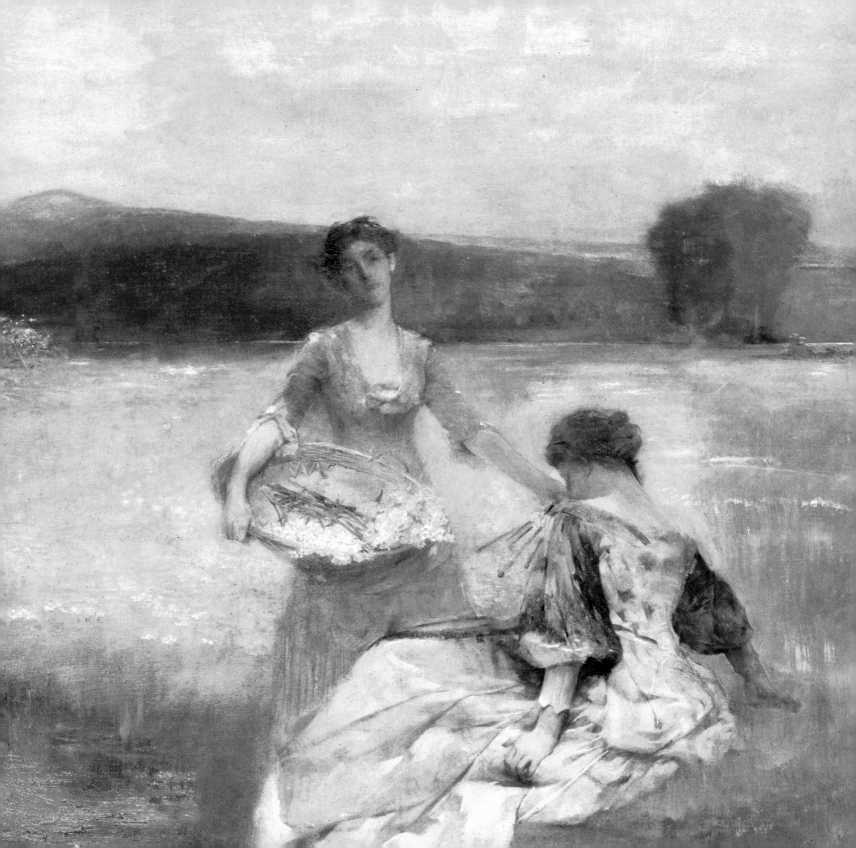

THOMAS WILMER DEWING

1851–1938

In the Garden

1892–94, oil
52.3 x 88.9 cm
Smithsonian
American Art
Museum, Gift of
John Gellatly

"The exquisite poem, 'In the Garden,' [is] one of the few perfect masterpieces which American figure painting has produced," wrote critic Sadakichi Hartmann in 1901, describing this mysterious painting, also known as *Spring Moonlight*. In the atmospheric moonlit haze, Dewing arranged three lovely women, each posed at a slightly different angle, each lost in her own reverie. The central figure carries a long wand, infusing the scene with intimations of magic. The artist used the same twenty-six-year-old model, known only as Ruth, for all the figures, alluding perhaps to the multifaceted nature of woman or to such classical triads as the Fates. Floating in the vaporous green grasses, the slender, elegant figures form a haunting, lingering vision of memory and melancholy.

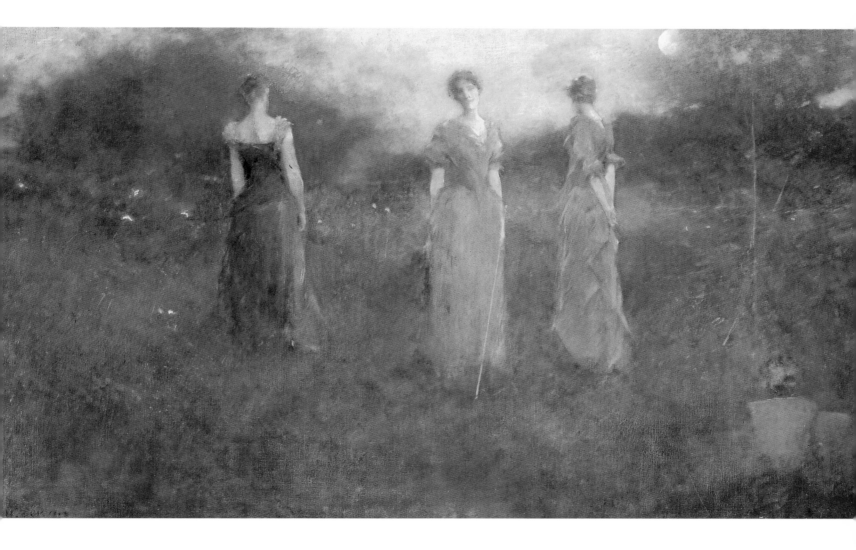

WILLIAM de LEFTWICH DODGE

1867–1935

Stepping in the Fountain

about 1916, oil
81.3 x 48.3 cm
Smithsonian
American Art
Museum, Gift of
Leftwich D.
Kimbrough

From about the age of twelve to twenty-seven, Dodge lived in Europe with his family, studying art in Paris and Berlin. After journeys back and forth to Europe and many commissions for mural paintings, Dodge found a house at Setauket, Long Island, which he called Villa Francesca.

This painting, executed in a brightly illuminated, spontaneous impressionist style, depicts Dodge's daughter Sara stepping into the fountain at the villa to cool her feet on a hot day. Directly in front stands a cast of a bronze statue of the Greek god Pan, made for the garden by the sculptor Frederick MacMonnies, who worked with Dodge in France at the end of the nineteenth century. Dodge cleverly positioned his daughter's face, Pan's head, and the water-spouting head on a diagonal, leading our eyes across the picture plane. The plant fronds complete this decoratively patterned, charming, and intimate portrait.

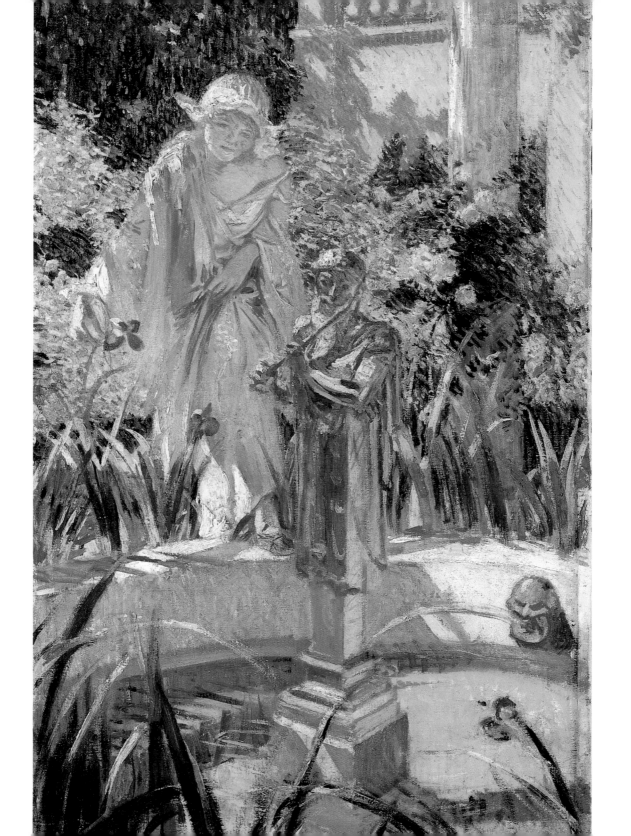

ARTHUR WESLEY DOW

1857–1922

The Hill Field

1908–10, oil
35.5 x 50.5 cm
Smithsonian
American Art
Museum

Dow's delight in wet, rich oil paint and his gift for arranging pictorial elements expressively are revealed at first glance in this small landscape of a country field in the moist freshness of a summer morning. The artist had been curator of Japanese art at the Museum of Fine Arts, Boston, and later published *Composition*, a book on the principals of design. Dow's own command of design emerges vividly in *The Hill Field*. In a composition dominated by patterns of brush strokes and objects he evokes a sense of space and movement by directing our gaze around the painting. Our eyes move from the green haystacks in the foreground to the orange stacks beyond and on toward the trees, lake, hills, and finally to the sky, where the rising sun suffuses distant clouds with a pink glow.

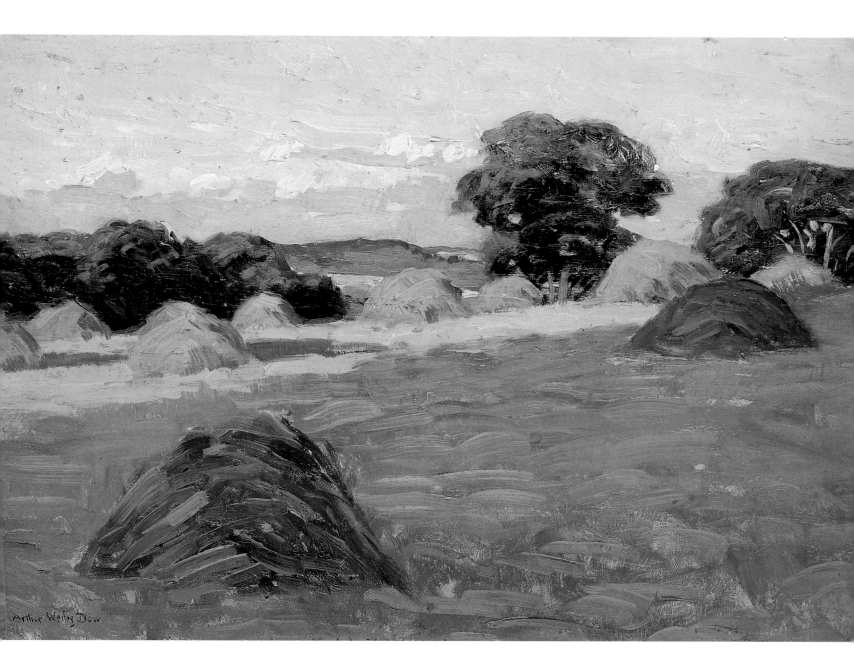

FREDERICK CARL FRIESEKE

1874–1939

Nude Seated at Her Dressing Table

1909, oil
162.2 x 131.1 cm
Smithsonian
American Art
Museum, Gift of
the Sidney Avery
and Diana Avery
1978 Trust

Frieseke's curvaceous nude echoes the lines of her elegant glass-top dressing table. Nudes were the artist's favorite subject, which may explain why he spent most of his life in France after studying in Chicago and New York City. "I stay on [in France]," he wrote, "because I am more free and there are not the Puritanical restrictions which prevail in America." Nonetheless, Frieseke did not consider himself an expatriate like his acquaintance James McNeill Whistler.

Frieseke painted this figure in his Paris apartment, emphasizing the privacy of the bedroom scene. We observe the young woman from a slightly elevated perspective; the parts of her face and bosom that seem at first tantalizingly inaccessible to our eyes are reflected in the mirror. The artist's painting style, as well as the choice of a voluptuous woman, reveals his interest in the French impressionist Auguste Renoir. The image crackles with risky, striking colors; Frieseke juxtaposes the reds of the model's abundant mane with the turquoises in the necklace on the table and the woman's ring. Charming and sensual, Frieseke's nude embodies the American fascination with the pleasures of Paris.

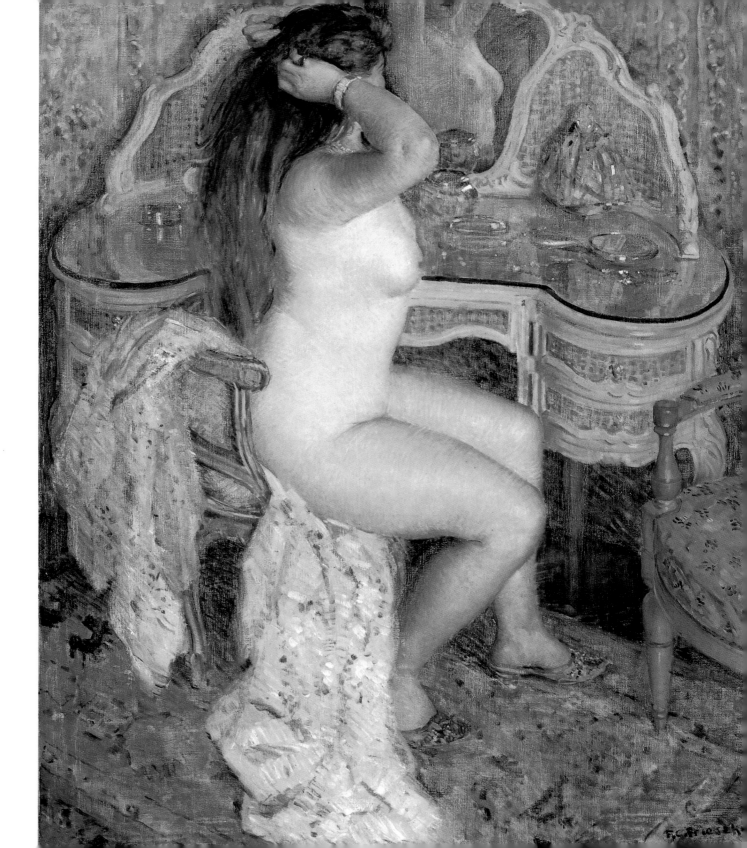

DANIEL GARBER

1880–1958

Tohickon

about 1921, oil
132.7 x 143 cm
Smithsonian
American Art
Museum, Bequest of
Henry Ward Ranger
through the National
Academy of Design

Garber's works were so esteemed that this canvas was accepted into the museum's collection not long after it was painted. The view of a village perched on the hillside above Tohickon creek and gorge, near New Hope, Pennsylvania, is characteristic of the radiantly colorful, loosely impressionist landscapes for which the painter was known. Born in Indiana, Garber became a popular member of an informal artist's colony centered in New Hope on the banks of the Delaware River. His light-struck, carefully drawn images possess a decorative quality that sets them apart from the work of his colleagues. This composition is especially clever: we gaze upward at the houses and church that dot the hill from our position across the creek and behind the silhouette of a double-trunked tree that frames the panorama. The dark, cool shade creates an intense contrast with the brilliantly illuminated distance; the scene shimmers with the heat of a summer's day.

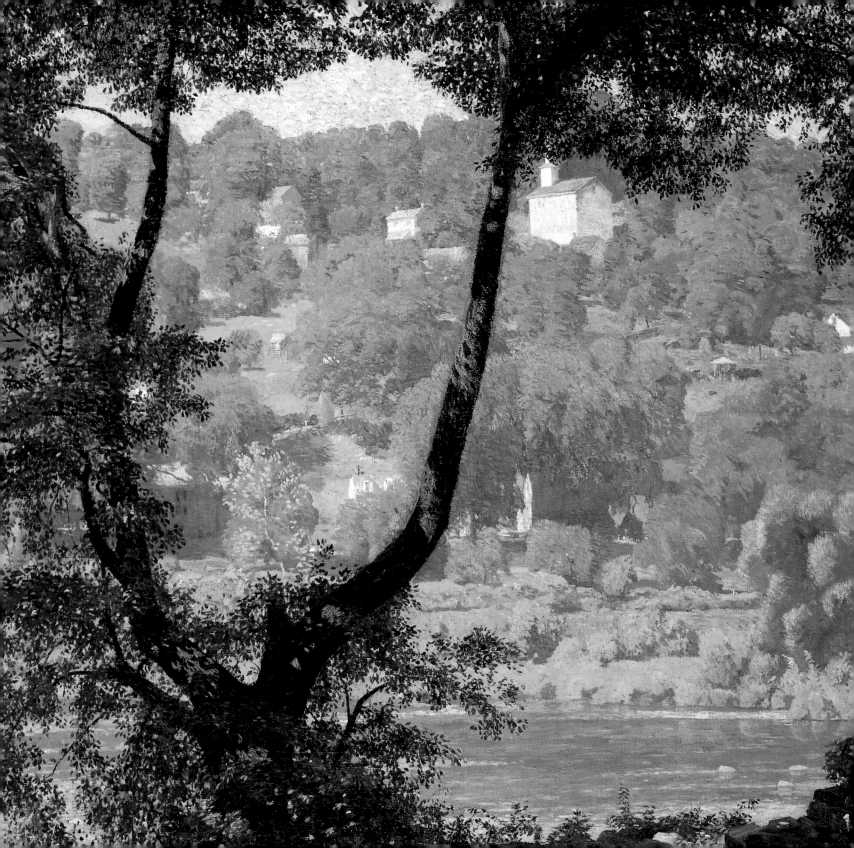

BIRGE HARRISON

1854–1929

Winter Sunset

about 1890, oil
38.7 x 59.4 cm
Smithsonian
American Art
Museum

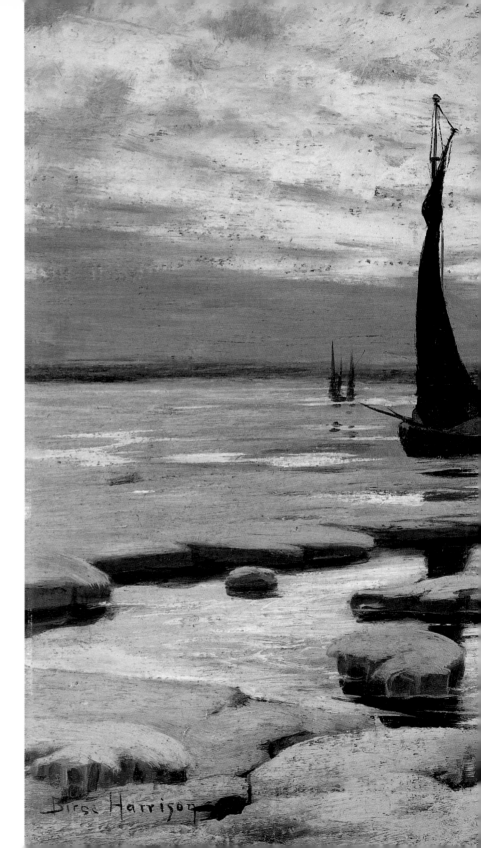

CHILDE HASSAM
1859–1935

Celia Thaxter in Her Garden

1892, oil
56.5 x 45.7 cm
Smithsonian
American Art
Museum, Gift of
John Gellatly

The lovely figure in Hassam's colorful outdoor scene is Celia Thaxter, a close friend of the painter. Daughter of a lighthouse keeper on Appledore Island, part of the Isles of Shoals off the New Hampshire coast, Thaxter was as well known for her poetry as for her exquisite garden. Seemingly a landscape, Hassam's picture is actually a portrait, not one that details every facial feature, but one that seizes the essence of the white-haired beauty in her flowing gown. By blending Thaxter into the blossoms, the painter identifies her with the things she cared for most: her garden and the sea.

Hassam vividly evokes the garden's tangled vitality, with its riotous accents of scarlet poppies. Although Thaxter died two years after this picture was painted, Hassam returned to Appledore every year until 1913, always seeking the freshness and peace of the island.

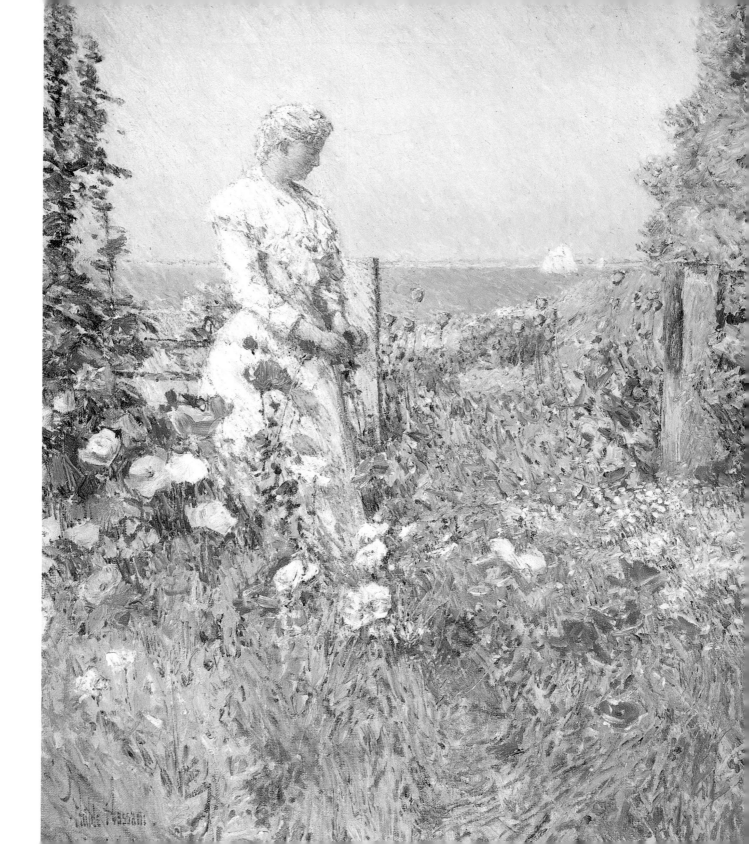

CHILDE HASSAM

1859–1935

Maréchal Niel Roses

1919, oil
67.2 x 82.8 cm
Smithsonian
American Art
Museum, Gift of
John Gellatly

Hassam's model, possibly a young woman named Kitty Hughes, sits at the round, highly polished mahogany table in the artist's studio in New York City, her eyes rapturously riveted on two vases of Maréchal Niel roses, which seem to return her admiring gaze. Named for Napoleon III's secretary of war, these beautiful hybrid roses bear golden yellow petals and an intense fragrance. In the background, a picture of another woman echoes the model's profile. Her yellow hair glitters in a luminous halo, and the basket weave of her elongated fingers emphasizes the discordant note of her turquoise ring. Combining these details with his staccato brush strokes and scintillating colors, Hassam overwhelms us with the sensuous delight of sight and scent.

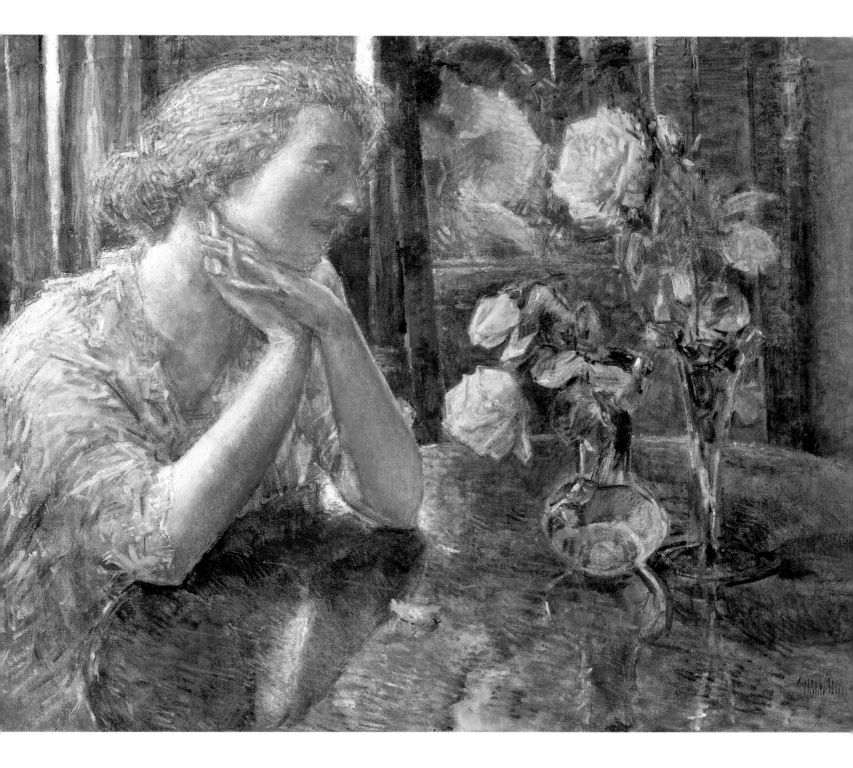

CHILDE HASSAM

1859–1935

Pomona

1900, oil
94.3 x 64.2 cm
Smithsonian
American Art
Museum, Gift of
John Gellatly

Hassam was well known for his views of New York, Boston, and Paris, and for his country scenes of Appledore, an island off the coast of New Hampshire. When he was in his early forties, however, Hassam turned increasingly to painting the nude, often giving his works mythological titles from the classical past, as in *Pomona*.

Pomona was the ancient Italian goddess of fruit trees. Here she sits against a cloud-filled sky, her hands full of fruit-bearing branches. The fruit, as well as her classical profile and regal bearing, reveal that she is more than just a nude model. Even Hassam's brush strokes contribute to the figure's dignity; they are restrained and horizontal, laid down in a measured pattern that is offset by the more irregular lines of the leaves. The picture's classicism aligns it with the turn-of-the-century American interest in the revival of Renaissance ideals and signals the breadth of Hassam's painting styles and subjects.

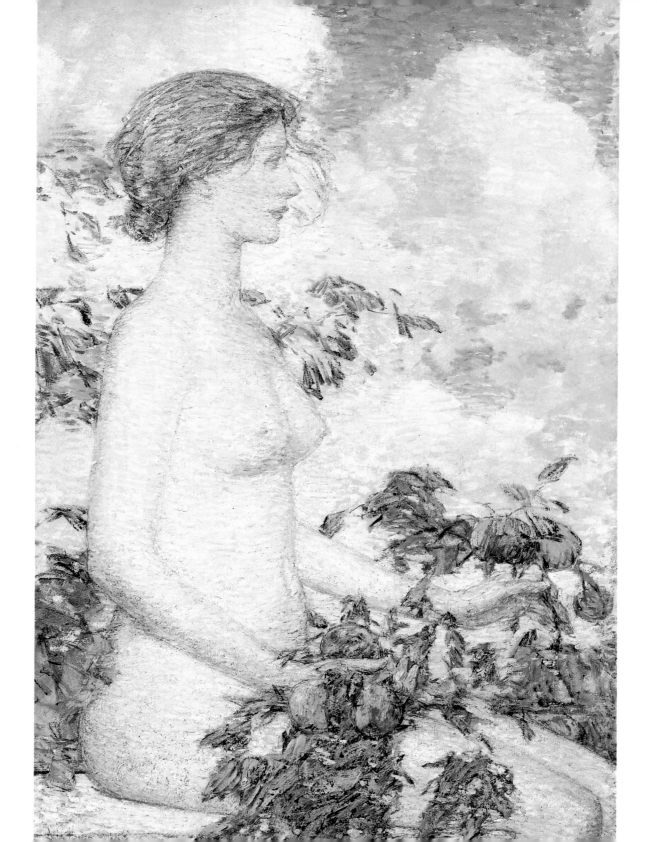

Ponte Santa Trinità

1897, oil
57 x 85.3 cm
Smithsonian
American Art
Museum, Gift of
John Gellatly

Hassam painted this work in 1897 on a trip to Europe, where he singled out the continent's important historical and artistic monuments such as the Ponte Santa Trinità, in Florence. Here the painter's easel looks east to the famous Ponte Vecchio, which is visible under the bridge span at upper right. The bold composition emphasizes the curves formed by the underpasses of the bridge as it arcs across the canvas. Hassam's impressionistic style emerges in the short, descriptive brush strokes seen in the pale green and ice-yellow reflections of the water. The artist used longer strokes for the bridge and for the boats that he angled away from the viewer in order to suggest depth.

More than a picturesque view, this bridge carried special meaning for the city: Michelangelo sketched the basic design, which was then executed by the architect Bartolommeo Ammanati under the patronage of Cosimo de' Medici. Grandly spanning the width of the Arno River, the Ponte Santa Trinità symbolizes the glory of Renaissance Florence.

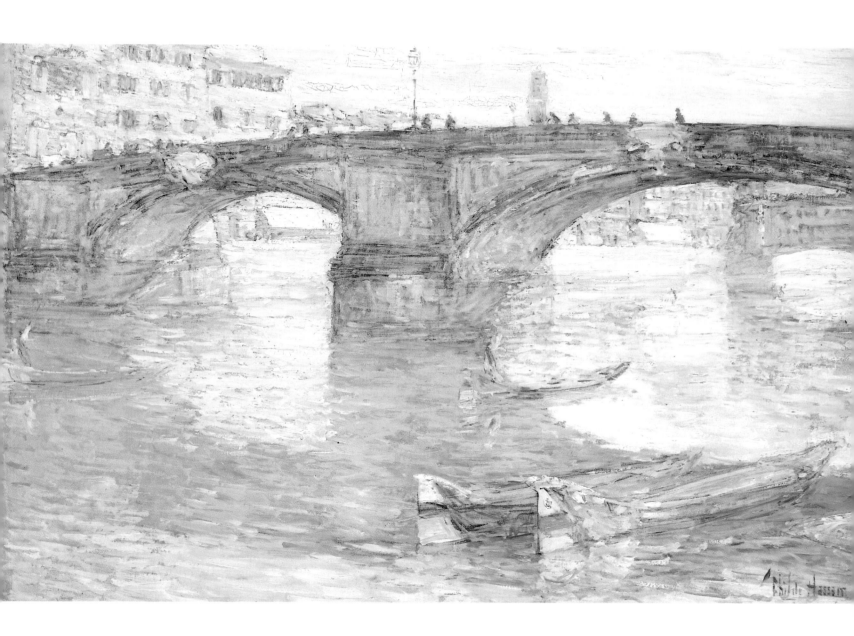

CHILDE HASSAM

1859–1935

The South Ledges, Appledore

1913, oil
87 x 91.6 cm
Smithsonian
American Art
Museum, Gift of
John Gellatly

On a summer day, an elegant young woman perches on a ledge of craggy boulders overlooking the sea. She gently tilts her hat to keep the sun and marine breeze from her face. A daub of white paint suggests a lone sailboat, which punctuates the horizon at upper right.

Like the European impressionists, Hassam used strokes of color to capture the ever-changing effects of light and atmosphere. After studying in Paris, he returned to America, where, in 1898, he joined the Ten, a group of painters who specialized in exploring the impressionist style. He summered for decades on Appledore Island, one of the Isles of Shoals, a few miles off the coast of New Hampshire, and it was there that Hassam painted this vivid glimpse of a New England summer.

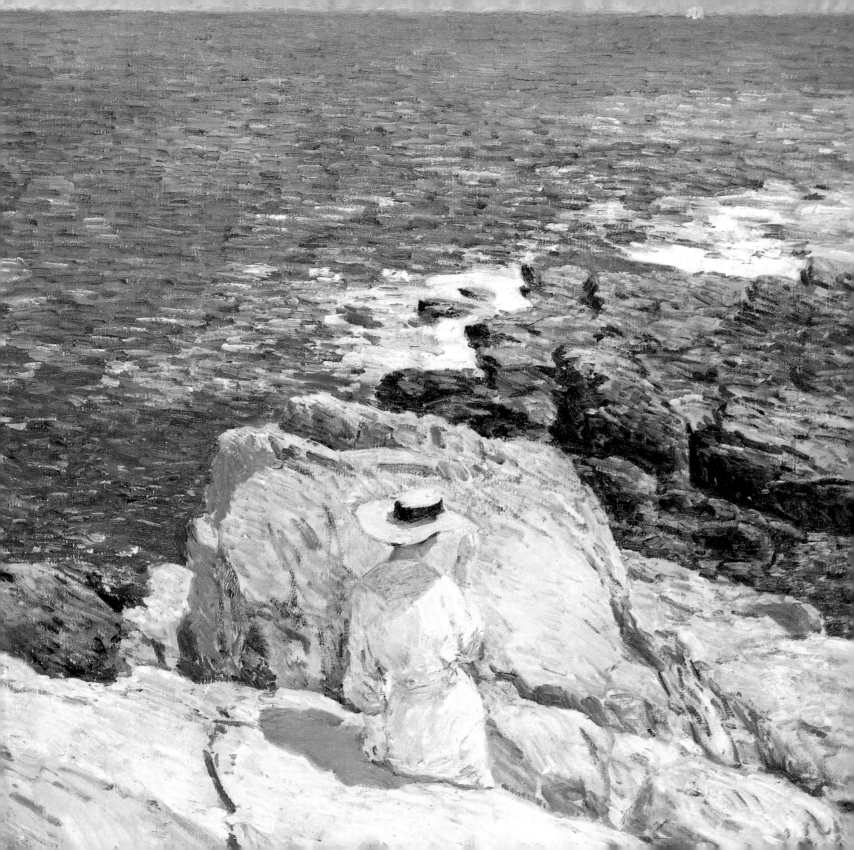

CHILDE HASSAM
1859–1935

Tanagra (The Builders, New York)

1918, oil
149.2 x 149 cm
Smithsonian
American Art
Museum, Gift of
John Gellatly

Hassam explained the meaning of this sizeable picture at some length in a letter: "Tanagra—the blond Aryan girl holding a Tanagra figurine in her hand against the background of New York buildings—one in the process of construction and the Chinese lilies springing up from the bulb are intended to typify and symbolize growth—beautiful growth— the growth of a great city hence the subtitle The Builders, New York."

In *Maréchal Niel Roses* the same regal model and the same luxurious setting create a poem of sight and smell. Here, by contrast, Hassam expresses patriotism and optimism during World War I. By juxtaposing the elegant terra-cotta statuette from the ancient Greek city of Tanagra with the builders outside his studio window, Hassam associates the grandeur of ancient Greece with the contemporary example of New York City as an icon of progress and American know-how.

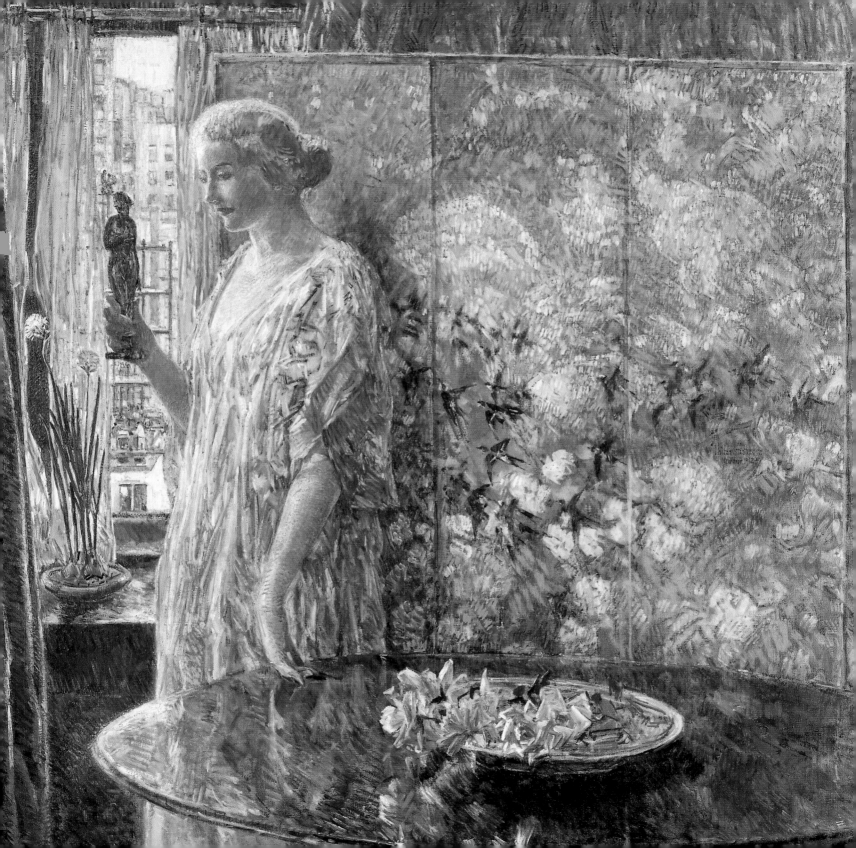

GEORGE HITCHCOCK

1850–1913

The Flight into Egypt

1892, oil
112.8 x 165.8 cm
Smithsonian
American Art
Museum

Hitchcock's painting was described in 1898 as "one of the best religious pictures of recent years." The glow around the woman's head suggests a halo, but as in many of his other religious works, Hitchcock's message is subtle. The beauty and simple modesty of the landscape signal we are not in the presence of ordinary mortals.

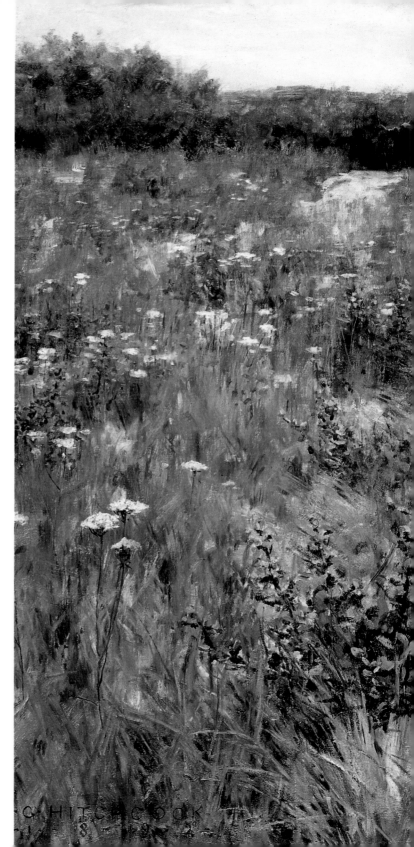

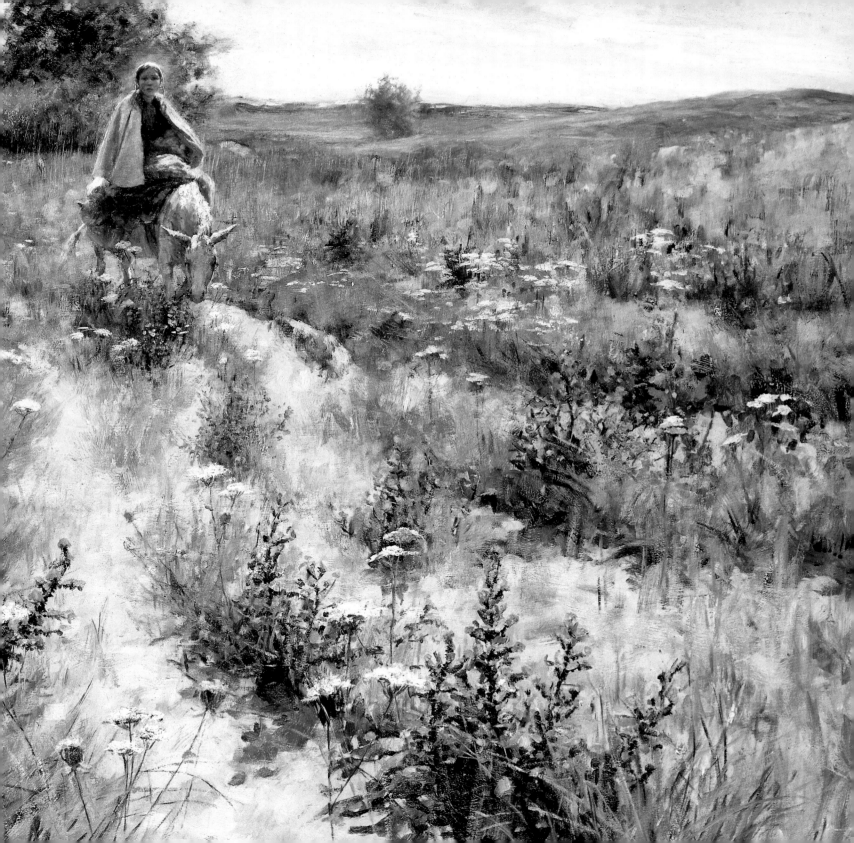

WILL H. LOW

1853–1932

Self-Portrait at Montigny

1876, oil
55.1 x 45.7 cm
Smithsonian
American Art
Museum, Bequest of
Henry Ward Ranger
through the National
Academy of Design

The year he painted this self-portrait, Will Low described himself as working with "serious purpose . . . to become a full-fledged artist." Low's "serious purpose" emerges here, communicated in the artist's set jaw and the direct yet vulnerable expression in his eyes. At this time, Low had joined other American painters in an artists' colony at Montigny, near Grez, outside of Paris. He frequently invited friends to join him below the "leafy trellis" of his house to discuss art and drink wine. Low used the trellis, which had strong symbolic value for him, to create a vivid pattern in front of which he posed his own figure, wearing a French straw hat and cravat.

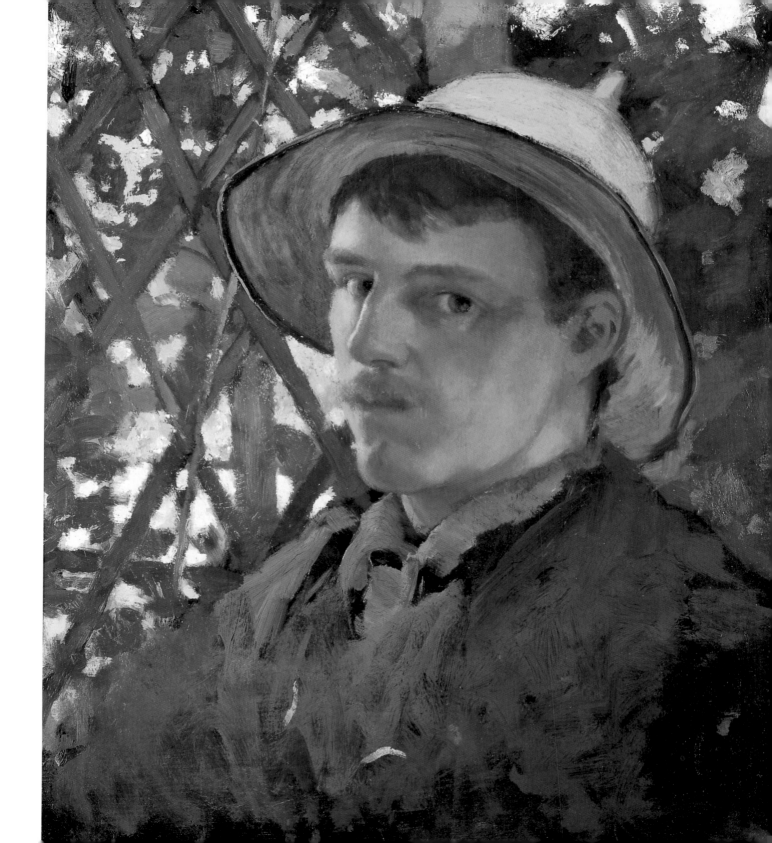

HOMER DODGE MARTIN

1836–1897

Evening on the Thames

about 1876, oil
46.4 x 76.6 cm
Smithsonian
American Art
Museum, Gift of
William T. Evans

Martin's expansive riverscape, with its bands of muted grays and yellows, recalls the subtle suggestivity of the work of the American expatriate James McNeill Whistler, whom he met in England in 1876. Some scholars have discerned the Houses of Parliament in the silhouetted buildings at left; otherwise, this twilight view across the flats to a river is devoid of landmarks, barren, deserted.

Martin began his career with tightly painted, detailed landscapes of the mountains and lakes of New York State, but here turned to a looser style. Water and sky occupy equal halves of the painting, intensifying our sense of nature's vastness and our smallness before it. Toward the end of his life, in the 1890s, Martin became increasingly ill and his eyesight declined. Only after his death was the talent of this virtually self-taught artist properly recognized.

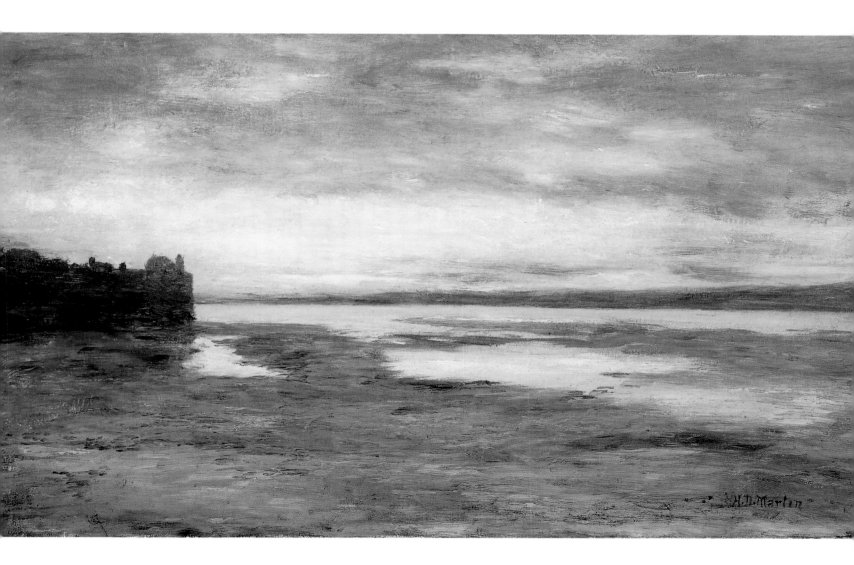

WILLARD L. METCALF

1858–1925

A Family of Birches

1907, oil

73.7 x 66 cm

Smithsonian
American Art
Museum, Gift of
William T. Evans

Impressionism suits *A Family of Birches,* in which the artist vividly renders the dappled sunlight of a summer day. Visible through the trees, a blue river with small houses perched on its banks winds into the distance. Metcalf's title humanizes the subject; he discerned that the birches were clustered together like a group of family members. Carefully drawn and tightly constructed, Metcalf's paintings earned praise from a critic who called him "the finest American painter of the New England countryside."

Metcalf's career was dotted with interesting interludes, including a trip in the 1880s to the Southwest, where he served as a naturalist and explorer for the Smithsonian Institution. After working as an illustrator, he then studied in Paris before returning home to join the group of painters called the Ten and to concentrate on painting impressionist New England landscapes such as this one.

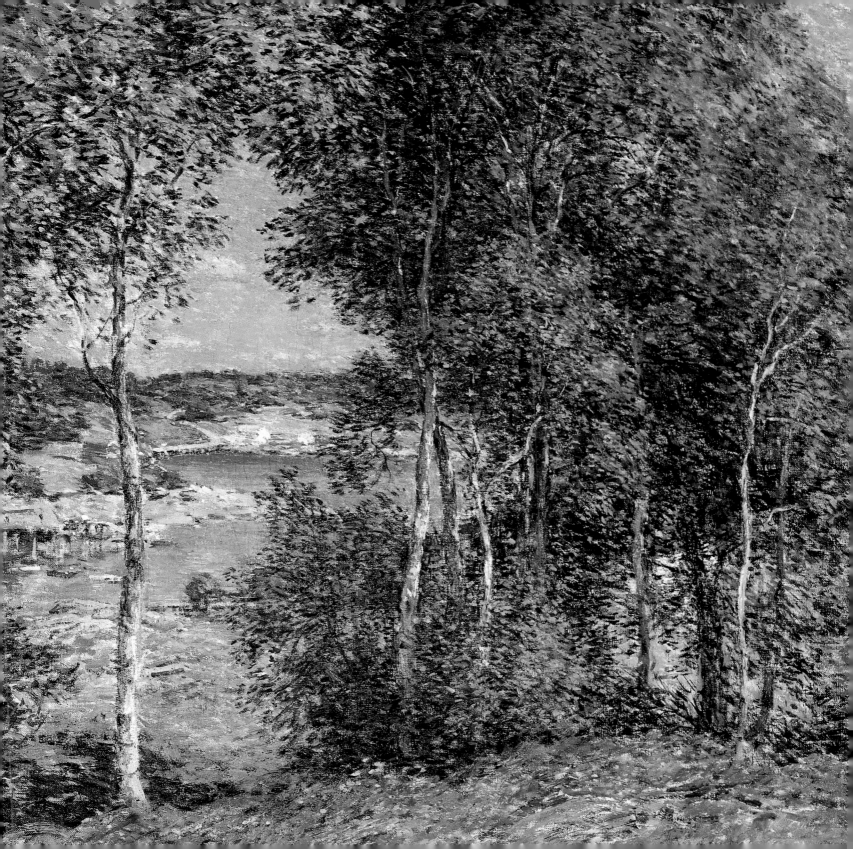

WILLARD L. METCALF

1858–1925

Snow in the Foothills

about 1920–25, oil
74.5 x 84.1 cm
Smithsonian
American Art
Museum, Gift of
John Gellatly

Like his artist friend John Twachtman, Metcalf fell under the spell of snow. Many of his landscapes explore its magical quality under different conditions of light and atmosphere. In *Snow in the Foothills*, Metcalf paints a thaw; snow recedes from the hilltop, and the water of a sinuous stream in the foreground breaks through the melting ice. The patchy treatment of this canvas, with its palette of cool whites, greens, blues, and sandy browns, effectively suggests the gentle gusts of chilly wind that push the clouds across the sky. The air still carries a bite, but spring is on its way.

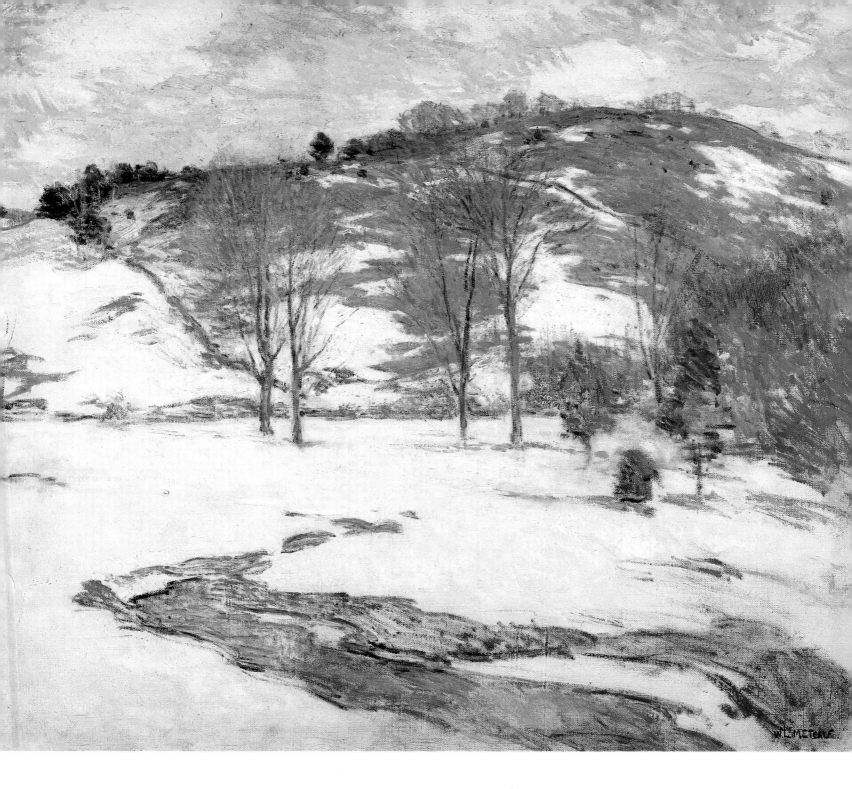

RICHARD E. MILLER

1875–1943

The Necklace

about 1924, oil
76.8 x 71.1 cm
Smithsonian
American Art
Museum

Richard Miller loved color and images of beautiful women sitting meditatively in sun-dappled interiors. Born in St. Louis, he joined Frederick Frieseke and other expatriate painters in Paris and then in the American artists' colony in the village of Giverny, where French impressionist Claude Monet had retired and was painting his water garden and lilies.

Adopting the same bright palette and technique of the impressionists, Miller explored the creation of pattern and light. In *The Necklace*, he further demonstrates his fascination with composition, juxtaposing the linearity of the Venetian blinds (each slat a different color) with the geometry of the open door and the mirror frame at right. Miller used the same pink dress with the black-bordered ruffles in many works, and often the same model, his wife Harriet. Although he claimed that "art's mission is not literary, the telling of a story," there is a strange intensity in Miller's focus on the woman, who seems to overpower her cluttered space.

Bequest of Henry Ward Ranger through the National Academy of Design

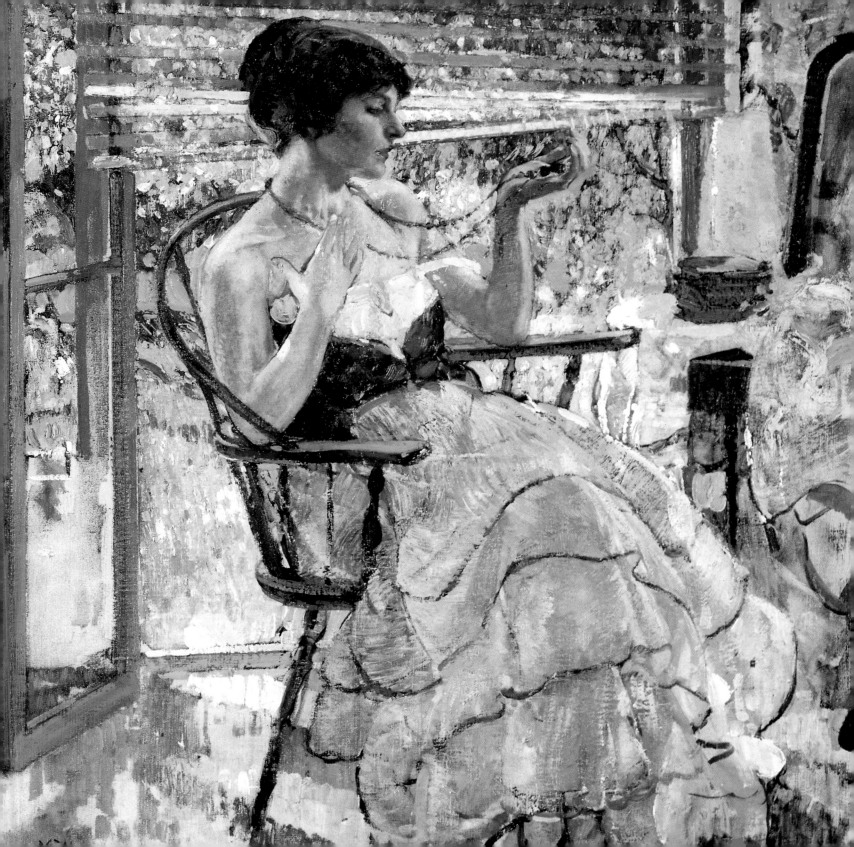

MAURICE PRENDERGAST

1858–1924

Summer, New England

1912, oil
48.9 x 69.9 cm
Smithsonian
American Art
Museum, Gift of
Mrs. Charles
Prendergast

The dizzying mosaic quality of Prendergast's style distinguishes him as one of America's most original artists. A brilliant painter and water-colorist as well as an insightful art theorist, the Newfoundland-born Prendergast divided his time between Europe, New York, and New England.

Summer, New England exemplifies the artist's gift for weaving a picture from layers of brush strokes that define space while emphasizing a lively surface texture. Contemporaries were frequently baffled by the seeming chaos of his images, but we recognize how curvy lines arranged in rhythmic harmonies evoke the sunny contentment of a summer's day in a world of happy children, well-dressed women, and lovely surround-ings. Prendergast often worked with his brother Charles, who carved many of the beautiful frames that grace Maurice's lighthearted images.

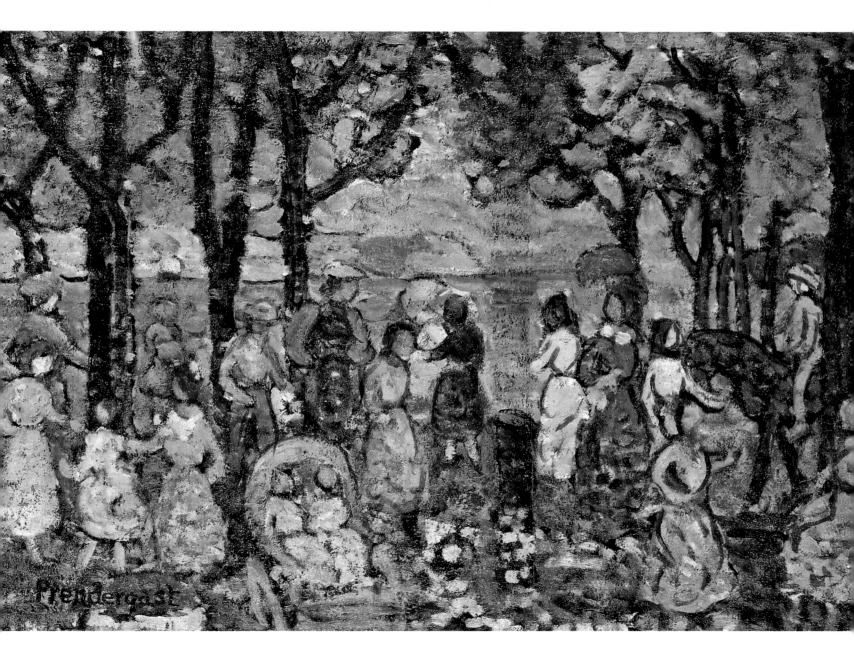

ROBERT REID

1862–1929

The Mirror

about 1910, oil
94.9 x 77 cm
Smithsonian
American Art
Museum, Gift of
William T. Evans

Calling him the "poet of frivolity," critic Sadakichi Hartmann simulta-
neously praised the magic of Reid's art and scorned it as frivolous, de-
void of philosophical substance. After studying in Paris, Reid returned
to New York City in 1890 where he turned his attention to large-scale
murals and images of women, earning from another critic the more sym-
pathetic label of "Decorative Impressionist."

In *The Mirror*, a model poses in profile before a painted Japanese fold-
ing screen. Her elegant off-the-shoulder dress emphasizes the sinuous
lines of her graceful neck and corresponds to the image of the crane in
flight. Her theatrically curved wrist supports a mirror that, in addition
to symbolizing vanity and the transience of earthly beauty, creates an
eloquent circle that enhances the overall composition. Moreover, the
woman's outstretched arm artfully echoes the train of her sumptuous
blue-green gown. In the end, poetry and significance reside in the
picture's harmony of color and design, its shimmering paint handling,
and its gentle, contemplative aura.

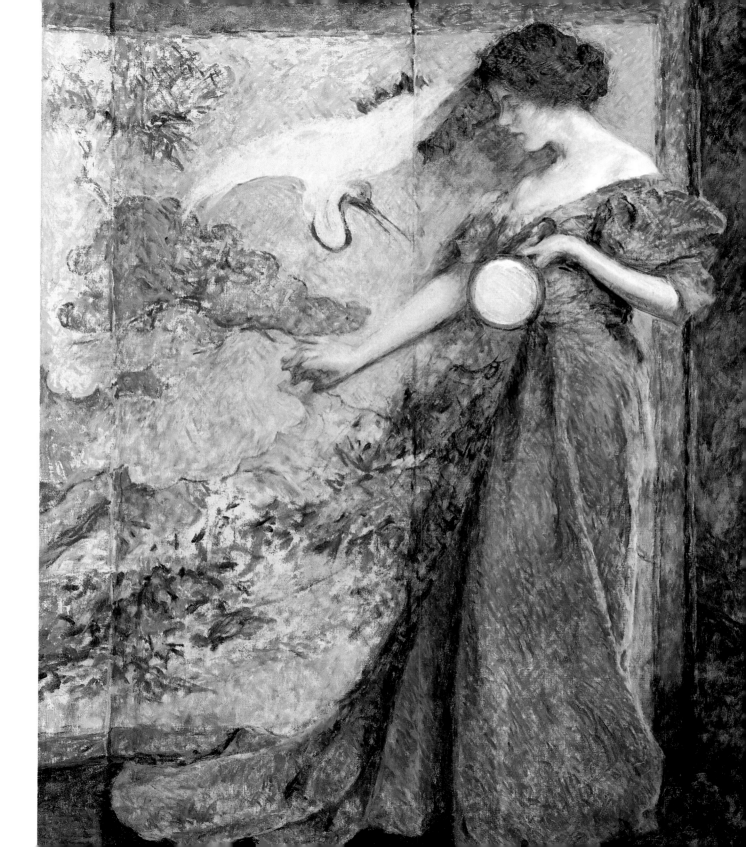

ROBERT REID

1862–1929

The White Parasol

about 1907, oil
91.4 x 76.2 cm
Smithsonian
American Art
Museum, Gift of
William T. Evans

The white-clad model (possibly Elizabeth Reeves, to whom Reid was briefly married) cradles a lavish bouquet of salmon-hued lilies and golden-rod while grasping with delicate fingers a white parasol that forms a bold pattern against the green foliage. Interestingly, near the arm holding the parasol is a pentimento, or composition change. Reid had initially painted the model's left forearm at a sharper angle, with the hand grasping the parasol higher up on the shaft. One can still discern the shadow of that first concept alongside the artist's final decision, indicating how carefully Reid calibrated his design. As in *The Mirror*, the artist demonstrates his gift for the splendidly decorative juxtaposition of art, nature, and feminine beauty.

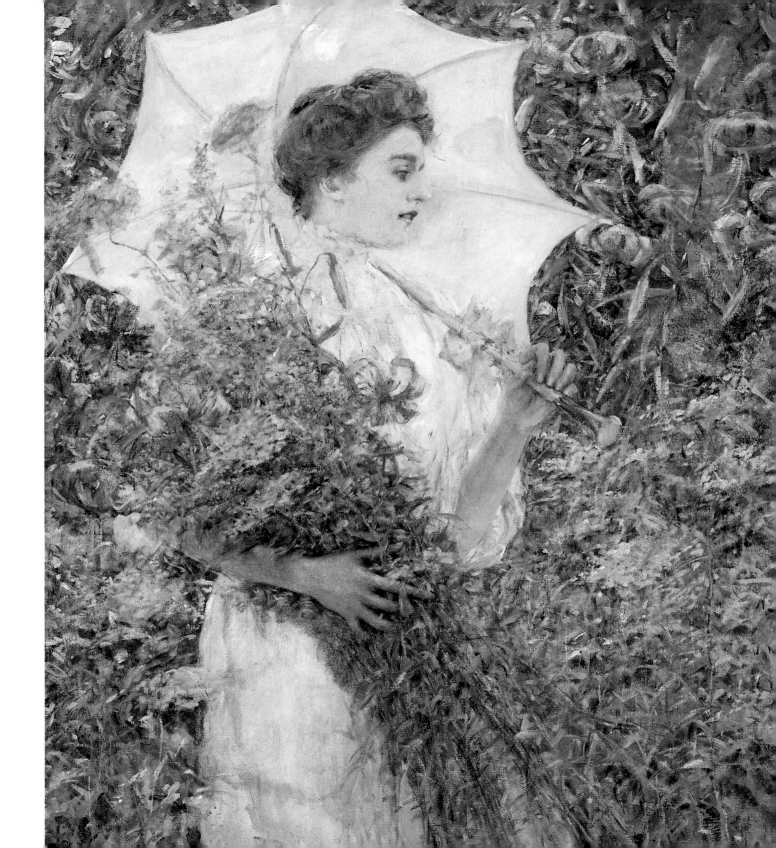

THEODORE ROBINSON

1852–1896

At the Piano

1887, oil
41.8 x 64.2 cm
Smithsonian
American Art
Museum, Gift of
John Gellatly

Painted in France, this contemplative scene of a young woman practicing the piano reprises a theme popular with European artists as well as with Robinson's friend James McNeill Whistler. Robinson himself made four versions of the subject—an austere room permeated with the invisible magic of music. The motif permitted Robinson to demonstrate his skill at designing monumental figural compositions in muted tones, reflecting his formal training in New York at the National Academy of Design and in Paris.

Robinson counterpoints the geometry of the stark room and its right angles with the flowing curves of the woman, the piano, and the flowers. The combination of these elements simultaneously evokes the senses of sight, hearing, and smell, adding a symbolic aspect to this seemingly simple image.

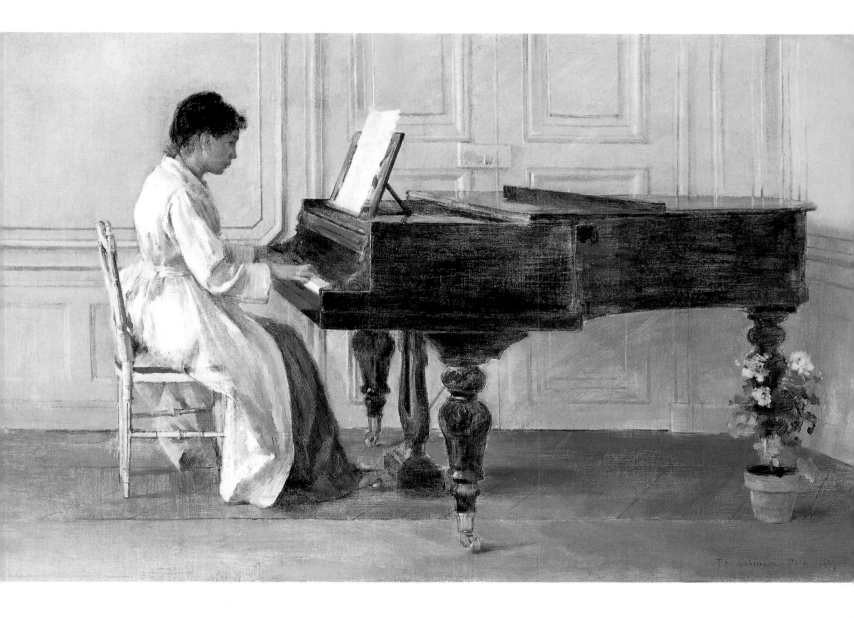

THEODORE ROBINSON
1852–1896

La Vachère

about 1888, oil
76.7 x 51.1 cm
Smithsonian
American Art
Museum, Gift of
William T. Evans

This colorful study, created for a larger version of the same theme, depicts a young peasant girl, head gently lowered, standing with her cow while engrossed in sewing. The subject, whose title means "cowherd," was a favorite of Robinson's. He worked in the impressionist style that he had learned the previous year in the village of Giverny under the tutelage of the French impressionist painter Claude Monet. Using patches of color that sit on the surface of the canvas, Robinson suggests the kind of meditative moment sought by Richard Miller in *The Necklace*, but instead places the figure in a countrified setting. There, side by side amid the sun-dappled trees and grass, girl and cow exist in complete equality and harmony with nature.

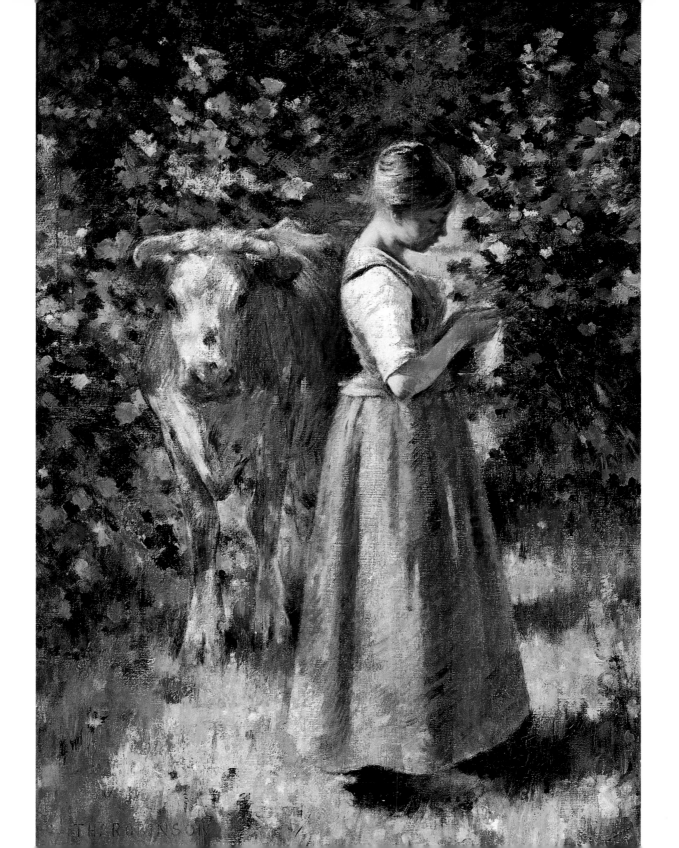

THEODORE ROBINSON

1852–1896

Old Church at Giverny

(detail)

1891, oil

45.8 x 56.1 cm

Smithsonian
American Art
Museum, Gift of
William T. Evans

Robinson spent many summers in the French village of Giverny, home to the impressionist painter Claude Monet, where he painted scenes of the town. Here, Robinson's rendering of the flower-covered hill with its bushes and trees is so vivid and engaging that one does not immediately perceive the steeple of the old stone church rising just to the left of center. Cutting off the steeple at the picture's top edge emphasizes the sense of its rising to the heavens, concentrating our focus instead on summer's luxuriance.

The underlying geometric composition effectively juxtaposes the diagonal hillside with the horizon, which is interrupted by the steeple and the triangular roof below. The thickly applied paint brings visual and tactile excitement to the picture surface. Robinson's paintings of picturesque European sites like this were extremely popular with American collectors seeking a blend of old-world aura with the extraordinary freshness and spontaneity of impressionism.

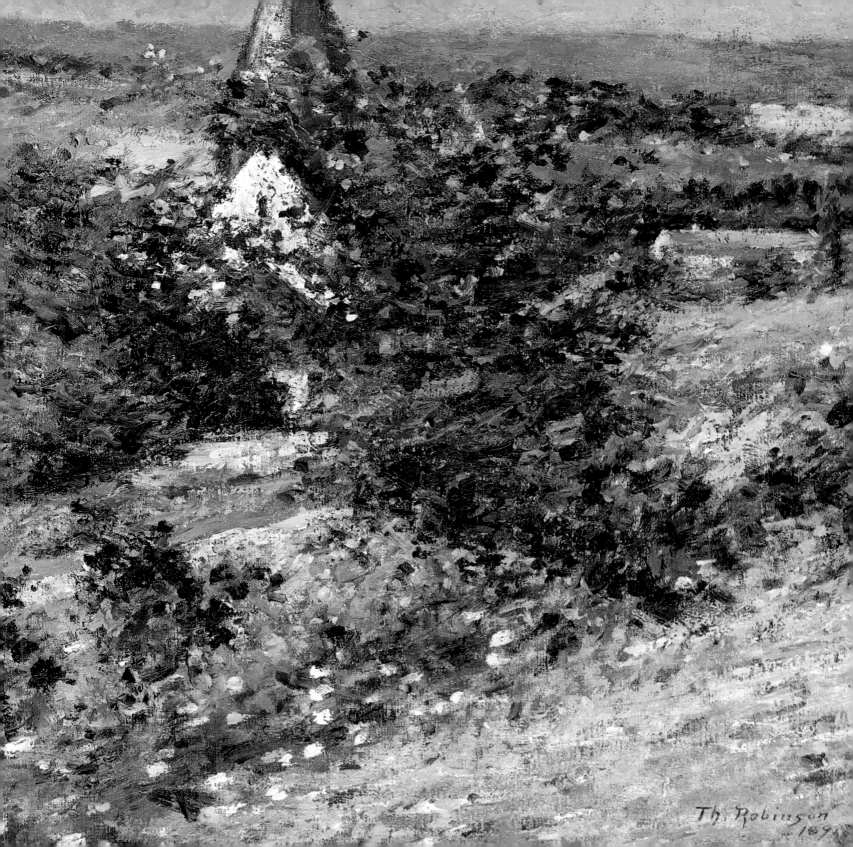

Th. Robinson
189-

HENRY OSSAWA TANNER

1859–1937

Haystacks

about 1930, oil
66.7 x 53.3 cm
Smithsonian
American Art
Museum, Gift of
Irwin M. Sparr

Executed with the spontaneity of a sketch, this work shows Tanner's style at its freest. Echoes of Claude Monet's haystacks reverberate in its conventional subject matter of wagon, haystacks, and trees. However, the dominant tonalities of blue, green, and brown lend a gently melancholic quality, a hint of poignancy, to this deserted corner of the field. Abstract patterns created by the broad shadow at the base of the stack on the left, strip of dark green in the middle ground, and odd, looming trees, somehow distance the scene from directly observed nature, revealing the painter's gift for transforming the ordinary through his personal vision.

Although Tanner's early work manifests the detailed, realistic manner he learned at the Pennsylvania Academy of the Fine Arts in Philadelphia, his style changed after moving for good to Paris in 1891. In Europe, and in the wake of a trip to the Holy Land in 1897, the African American artist cultivated a looser handling of paint, as he concentrated on genre scenes, religious imagery, and landscapes such as *Haystacks*.

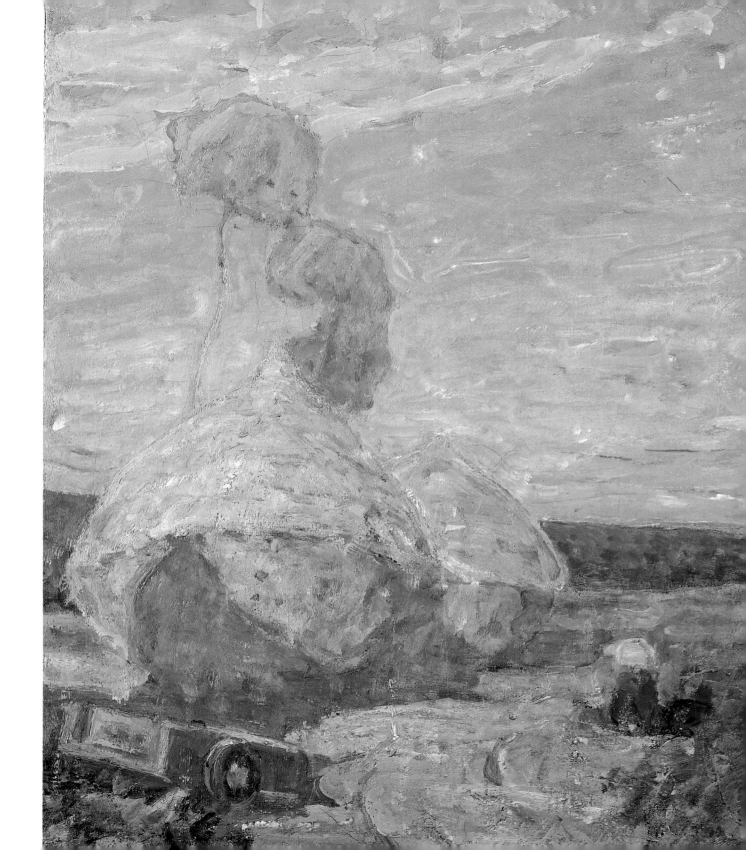

ABBOTT HANDERSON THAYER

1849–1921

A Bride

about 1895, oil
53.3 x 43.4 cm
Smithsonian
American Art
Museum, Gift of
John Gellatly

Thayer himself could not remember who this bride was. An acquaintance recounted a visit she made to his studio around 1918, where she found him ruminating over the sitter's identity. Thayer ultimately decided to send a photograph of the portrait to a lady he thought might have been the bride in question.

Since then, the picture has been shown to be a preparatory sketch for a larger, finished oil painting of Alice Maude Allen Atwater of Pittsfield, Massachusetts. In this society portrait, Thayer displays his gift for capturing a dignified pose and a good likeness. The unfinished quality of the work reveals his method of loosely creating the overall composition before elaborating the details. In the finished painting, the artist would scrupulously render the Japanese cloth of gold of the wedding gown with its ornamented bodice of Belgian rose-point lace.

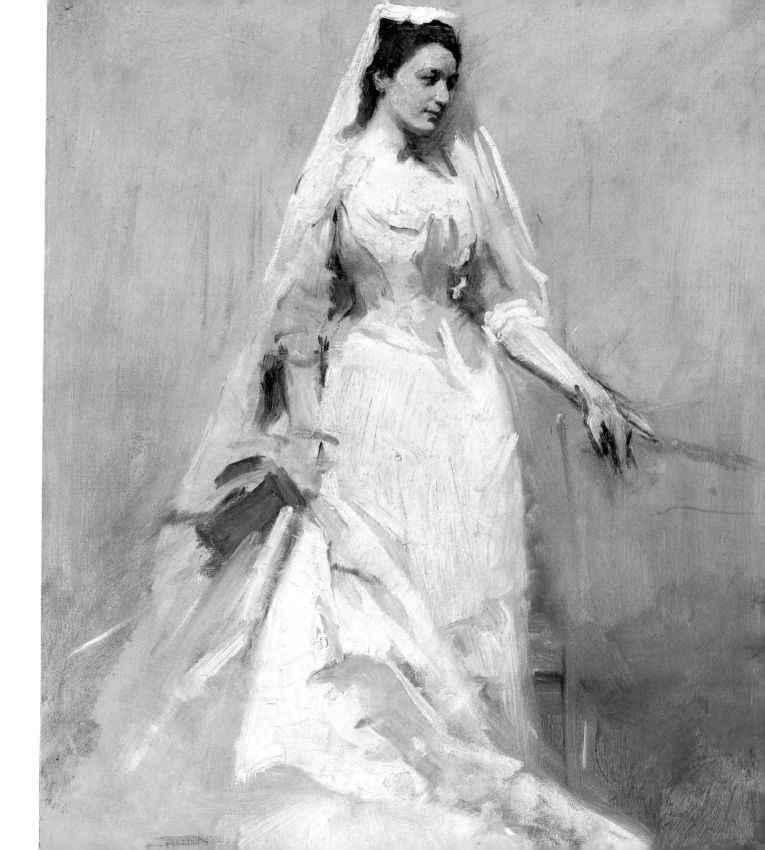

ABBOTT HANDERSON THAYER

1849–1921

Cornish Headlands

1898, oil
76.5 x 101.8 cm
Smithsonian
American Art
Museum, Gift of
John Gellatly

Thayer and his family visited Cornwall on the coast of England in the summer of 1898. Working outdoors, he painted two monumental views of the Cornish headlands, of which this is one, later describing the canvas as "one of a very few things I've done that I love."

Thayer used a palette of softly glowing opalescent hues popular at the end of the nineteenth century in media as varied as painting and stained glass. The mauve-tinted cliffs at left pick up the dusty rose-colored light on the clouds, where in the water an ice-turquoise shade slowly changes into a light bluish purple, ending in the pinkish purple horizon. At upper left, impasted daubs of white paint, perhaps squeezed directly from the tube, give material reality to sunstruck clouds. Covering his canvas with thin washes of paint, Thayer created a remarkably vast expanse of space, stretching from the cliffs to the farthest reaches of the eye. The landscape's extraordinarily abstract quality heralds a new, postimpressionist artistic vision.

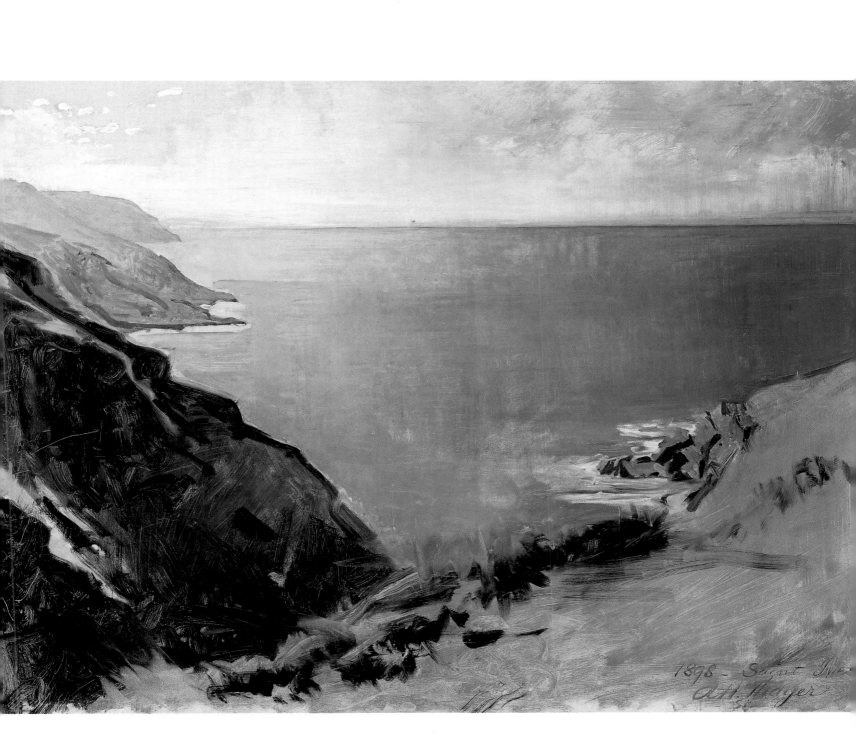

1898 – Saint Ives
A H Thayer

ABBOTT HANDERSON THAYER

1849–1921

Dublin Pond, New Hampshire

1894, oil
51.1 x 40.8 cm
Smithsonian
American Art
Museum, Gift of
William T. Evans

Boston-born Abbott Thayer moved to Dublin, New Hampshire, after the death of his first wife, Kate, in 1891. There, as part of a colony of artists, writers, and other intellectuals, Thayer lived at the foot of Mount Monadnock. After having spent years as a portraitist and painter of angels and allegories, the artist turned to landscapes that captured the beauty of his New Hampshire surroundings. *Dublin Pond* reveals Thayer's exquisite sensitivity to color and design; its verticality and abstraction evoke Japanese prints and screen paintings as well as the delicate compositions of Thayer's compatriot James McNeill Whistler. A dock at lower right launches a diagonal view toward the horizon, leading to the lyrical purple outlines of the mountains. The composition's simplicity complements the subtle opaline hues that cause the painting's surface to shimmer with light and inner life.

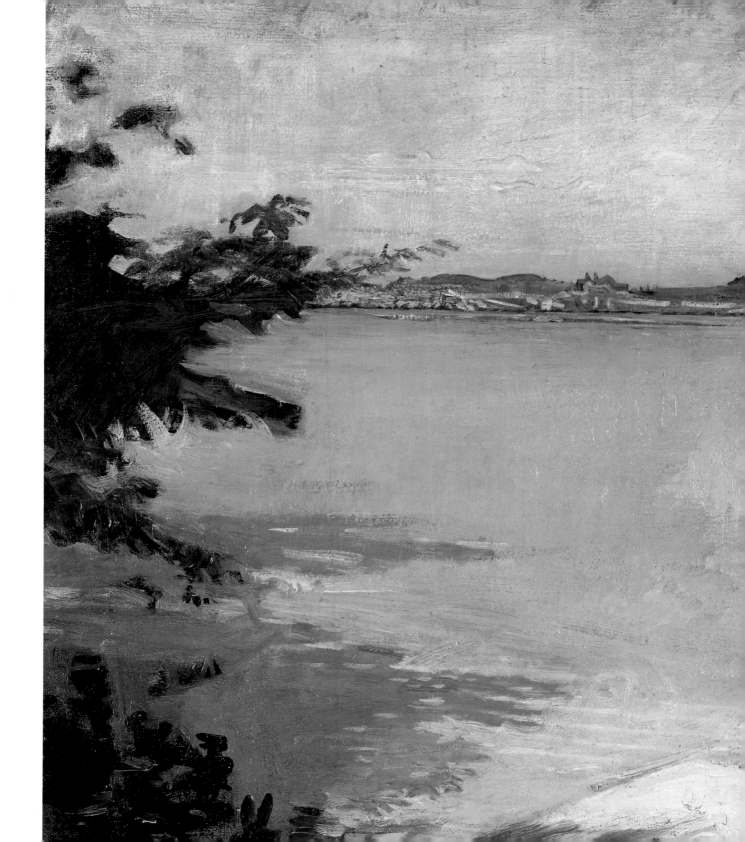

ABBOTT HANDERSON THAYER

1849–1921

Girl Arranging Her Hair

1918–19, oil
65.1 x 61.5 cm
Smithsonian
American Art
Museum, Gift of
John Gellatly

An introspective young woman inclines her head as she gently draws her long, silky brown hair back from her face. Her heavy-lidded eye and full lips offset the lines of her pure profile. A Greco-Roman-style robe drapes her bosom; its white folds are inflected with greens and pinks that echo the bloom in her cheeks. The sitter is Alma Wollerman, wife of Thayer's son, Gerald, and mother of his two grandsons. Alma frequently modeled for Thayer and for his friend Thomas Wilmer Dewing. Thayer painted numerous versions of this work but claimed he had "never painted anything to compare with this Botticelli-like Alma head." Like many of Thayer's enigmatic images of angels, this picture seems both sensual and ambiguous.

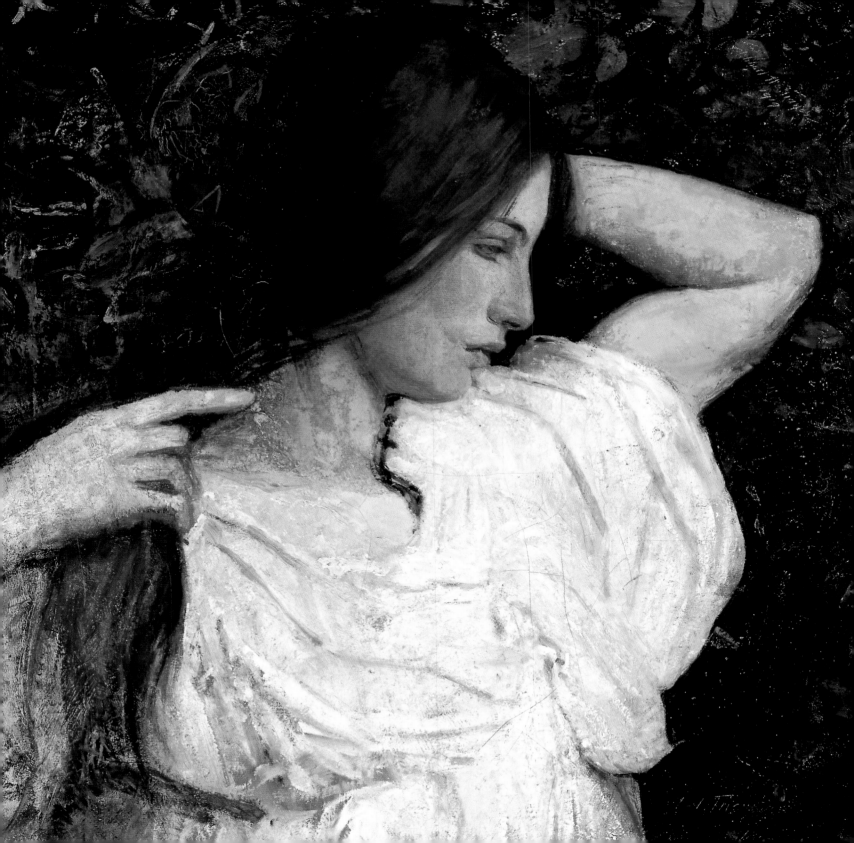

DWIGHT W. TRYON

1849–1925

November

1904–05, oil
50.7 x 76.1 cm
Smithsonian
American Art
Museum, Gift of
William T. Evans

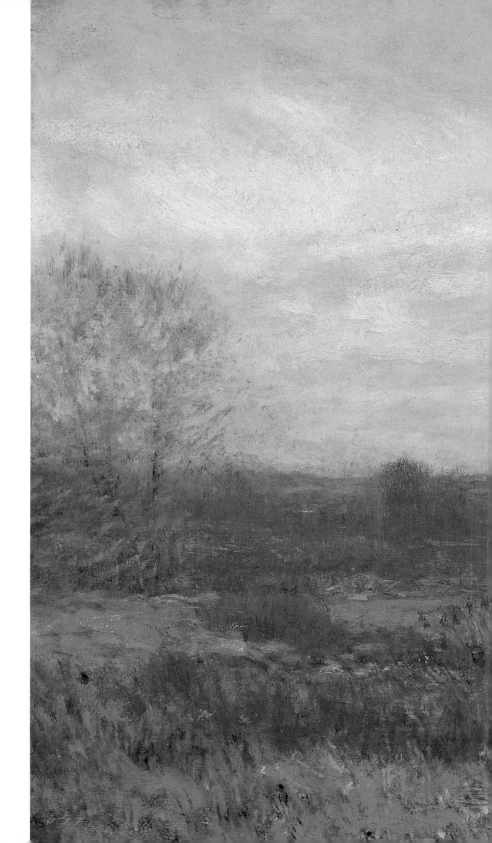

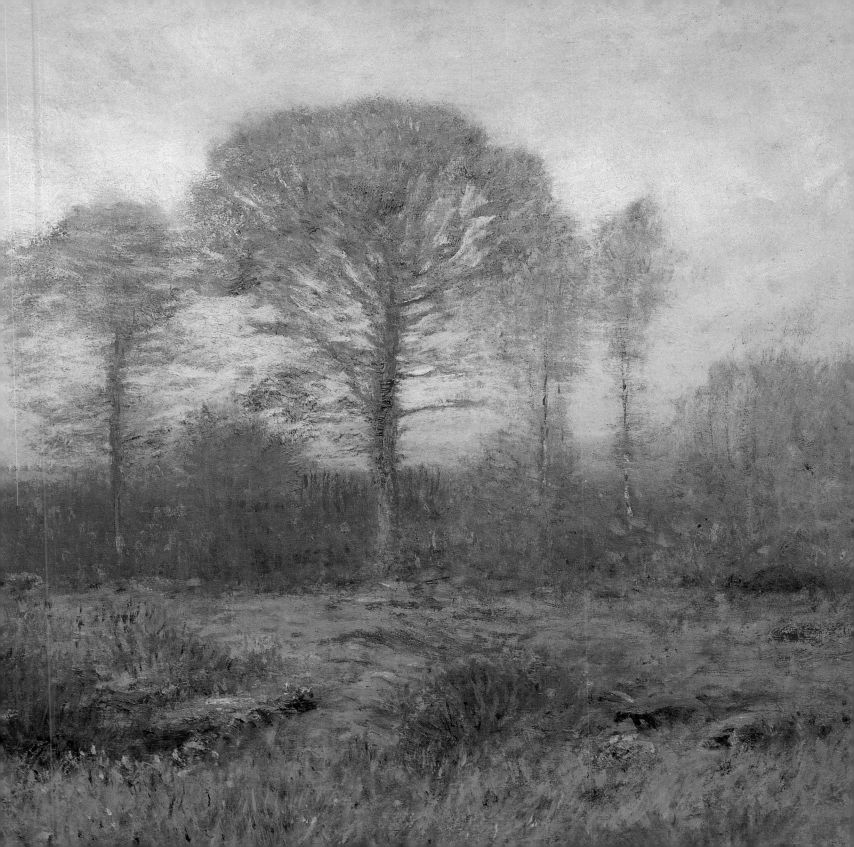

JOHN HENRY TWACHTMAN

1853–1902

On the Terrace

(detail)

about 1890–1900, oil

64.1 x 76.5 cm

Smithsonian
American Art
Museum, Gift of
John Gellatly

Twachtman painted this lyrical portrait of his family in their garden toward the end of his career, when he had settled on Round Hill Road in Greenwich, Connecticut, not far from New York City. After four trips to Europe, the painter delighted in returning home and representing scenes of life around him. The impressionist style he learned in France was perfect for capturing the gentle luminosity of a summer day. In this image, where, enhanced by a palette of soft colors, a mood of tenderness and contentment prevails, Twachtman celebrates the intimate connection of his 1840s farmhouse to the outdoors. Amid the rose arbor and the phlox border, a vine-covered trellis arches over his wife and three of their children, forming an emblem of motherly love. The zigzag of the rosebushes creates a lively and decorative surface pattern, and, more importantly, protectively encloses the white-clad figures. The family is as carefully tended and cultivated as the flowers.

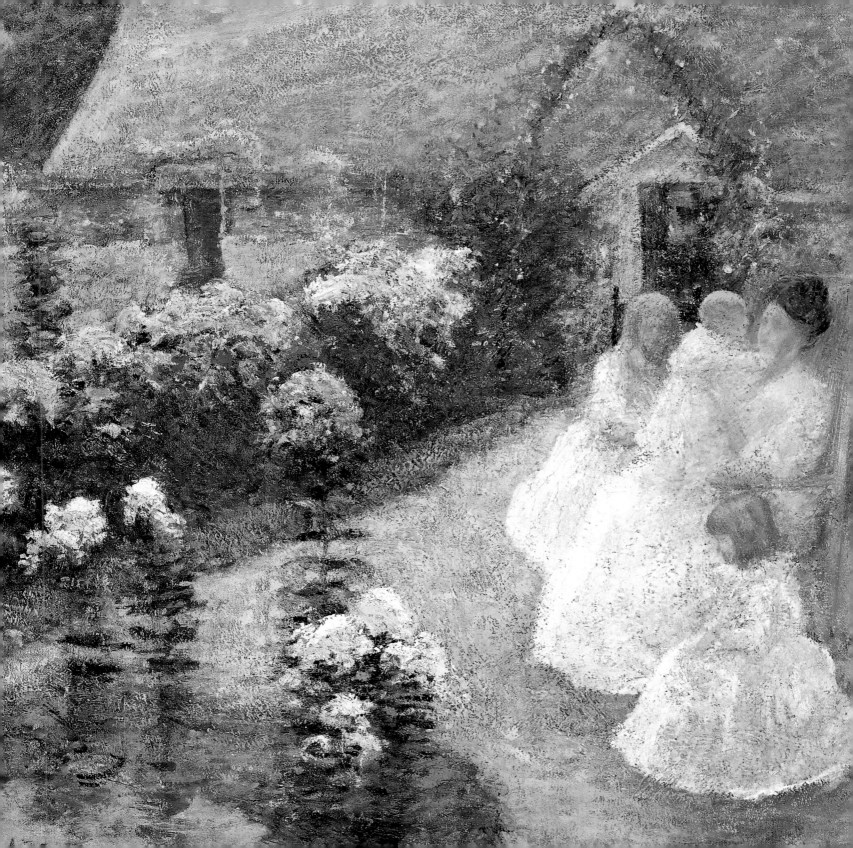

JOHN HENRY TWACHTMAN

1853–1902

Fishing Boats at Gloucester

1901, oil
63.7 x 76.7 cm
Smithsonian
American Art
Museum, Gift of
William T. Evans

The hardy painting style of this picture corresponds to its subject of sturdy fishing boats. Setting up his easel on a dock in the coastal Massachusetts village of Gloucester, the year before his death, Twachtman departed from his earlier poetic mistiness to embrace a technique based on powerfully applied strokes of dry pigment. He constructed a taut architectural composition, contrasting the diagonal dock, hulls, and booms with the vertical masts and the horizontal grouping of clapboard shacks on the wharf. Sandy-colored pigments with touches of green, maroon, violet, and blue convey the subdued light of an overcast day, the salty marine air, and the weathered wood of an austere New England fishing town. Twachtman's gift for evoking atmosphere and mood never deserted him.

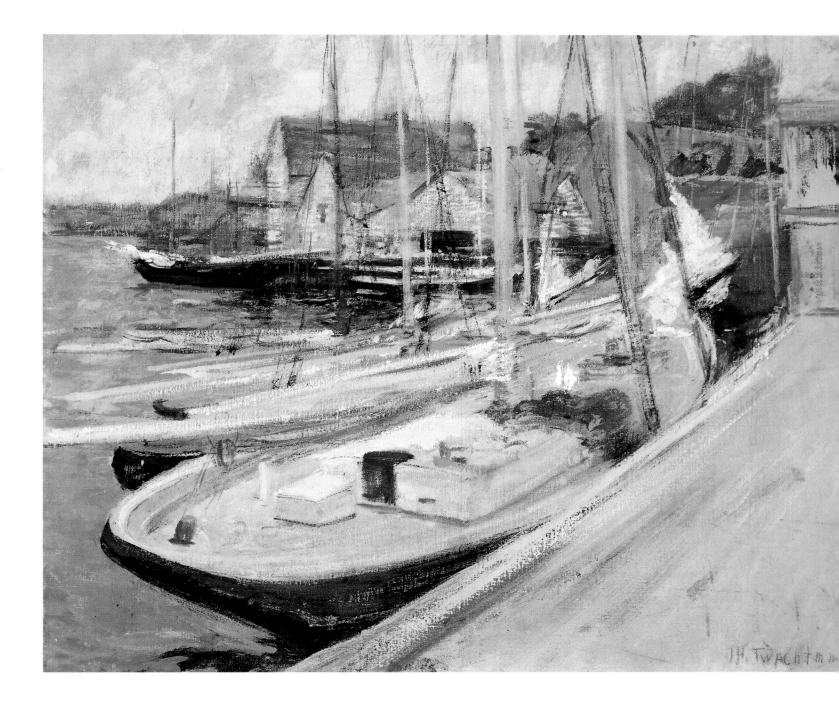

JOHN HENRY TWACHTMAN

1853–1902

Round Hill Road

about 1890–1900, oil
76.8 x 76.2 cm
Smithsonian
American Art
Museum, Gift of
William T. Evans

Twachtman was spellbound by snow. An ideal choice for experimenting with the exquisite subtleties of color and form, snowy landscapes comprise the major portion of his work. At first glance, this canvas seems virtually empty, a flat surface covered with barely visible abstract forms. Closer scrutiny reveals a snow-covered hill delineated by a sloping hedgerow behind which rises a pointed roof. A row of trees guides our eyes into the distance; the line between land and sky is barely discernible. A master in reproducing atmospheric effects, Twachtman veils the scene in a tonal haze of mist. Only after careful study do indistinct roses and violets emerge to describe a chimney or hedges and trees. The scene is at once ethereal and immediate; we delight in winter's bleak beauty but shiver from Twachtman's vivid evocation of a bitter chill, a moment when "all nature is hushed to silence."

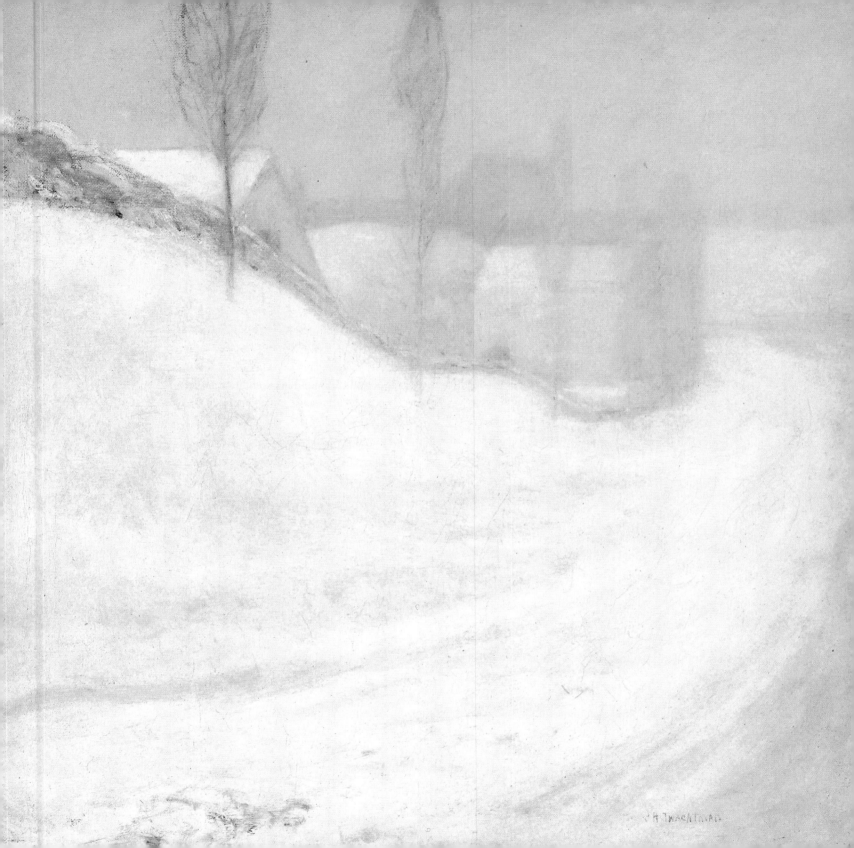

JOHN HENRY TWACHTMAN

1853–1902

Misty May Morn

(detail)

1899, oil

63.8 x 76.1 cm

Smithsonian
American Art
Museum, Gift of
John Gellatly

The only securely dated picture from Twachtman's Connecticut years, *Misty May Morn* exemplifies the artist's "tonalism," his exploration of lyrical atmospheric effects through a narrow range of color scales. Reminiscent of Claude Monet's impressionist paintings of poplars, this work shows spindly trees bordering a river amid a landscape of dissolved light. Casting thick layers of pastel greens, yellows, and blues, Twachtman transforms the canvas into a visual harmony of early spring hues. Some contemporary critics related the painter's fondness for asymmetry and abstraction, apparent here, to Asian art; others claimed to discern in the work's intimacy and quietude the influence of Zen Buddhism. With ethereal colors and indeterminate forms, Twachtman conveys his own delight in spring's dewy freshness and fragility.

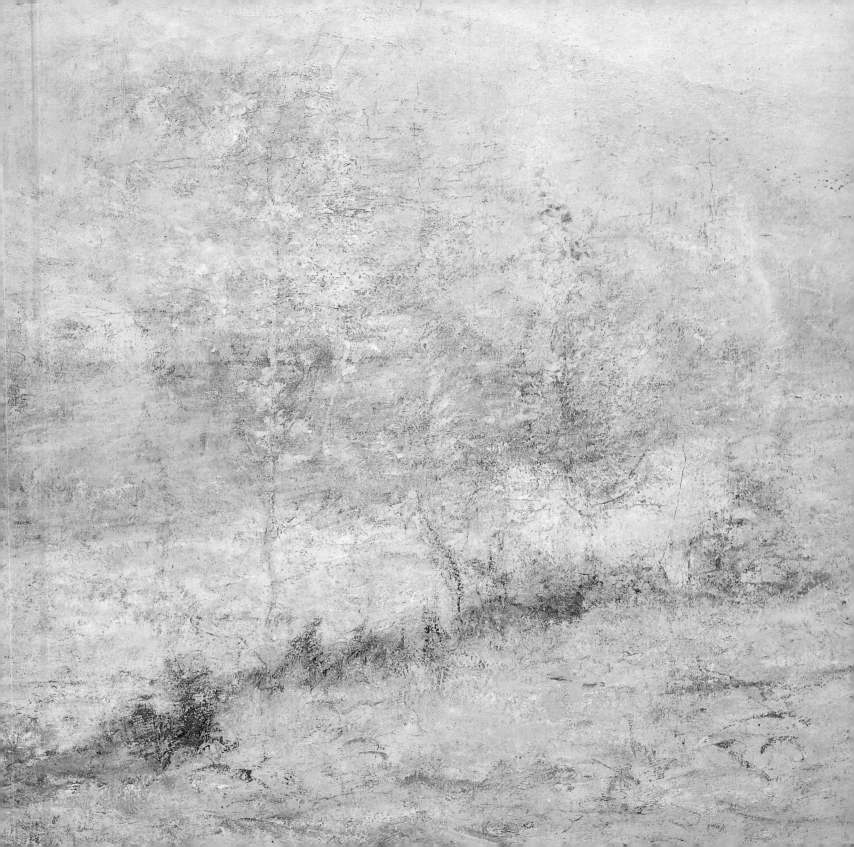

JOHN HENRY TWACHTMAN

1853–1902

The Torrent

about 1900, oil
64.1 x 76.5 cm
Smithsonian
American Art
Museum, Gift of
William T. Evans

Twachtman discovered this waterfall on the property he bought in
Greenwich, Connecticut, in 1889. Behind his house, Horseneck Brook
and the falls streamed by, and the artist painted them repeatedly, explor-
ing the varied effects of light, atmosphere, and the seasons on the flowing
water. Unlike other versions of this motif, where the falls are only one
feature in a larger landscape view, *The Torrent* accords them virtually the
entire picture space. The artist places us in the cascading foam directly
below the falls where our ears ring with the music of rushing water.

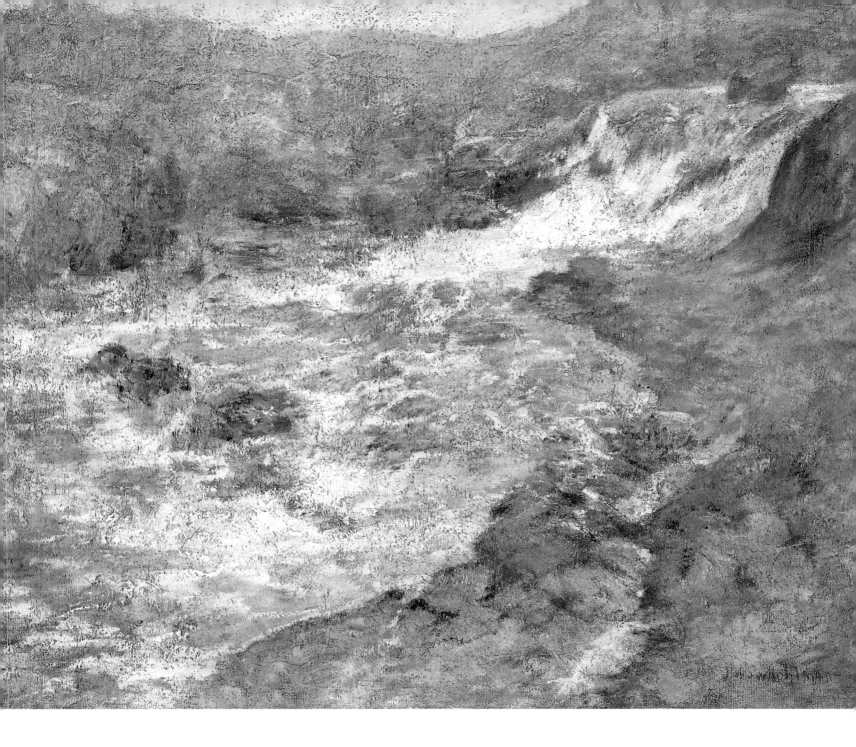

J. ALDEN WEIR

1852–1919

Upland Pasture

about 1905, oil
101.2 x 127.6 cm
Smithsonian
American Art
Museum, Gift of
William T. Evans

Upland Pasture was awarded the gold medal for landscape painting at the 1905 winter exhibition of the National Academy of Design in New York. The judges recognized the mesmerizing quality of this scene, with its blend of topographical description and autumnal moodiness.

Weir painted the pasture near his own home in Branchville, Connecticut, endowing a simple scene with visual intensity. The diagonal boulders in the foreground lead our eyes up toward the two brown cows grazing at the top of the hill. Weir adds dramatic impact to the picture by contrasting the cloud-cast shadows with brightly lit sections. Tiny touches of orange-red paint in the tree at right and the expressive brushwork give texture to the canvas, recalling Weir's interest in impressionism. Many of Weir's artist friends, including Childe Hassam, John Twachtman, Theodore Robinson, and Emil Carlsen, visited him at his Branchville farm in the 1880s and 1890s, painting together outside during the day and playing dominoes late into the night.

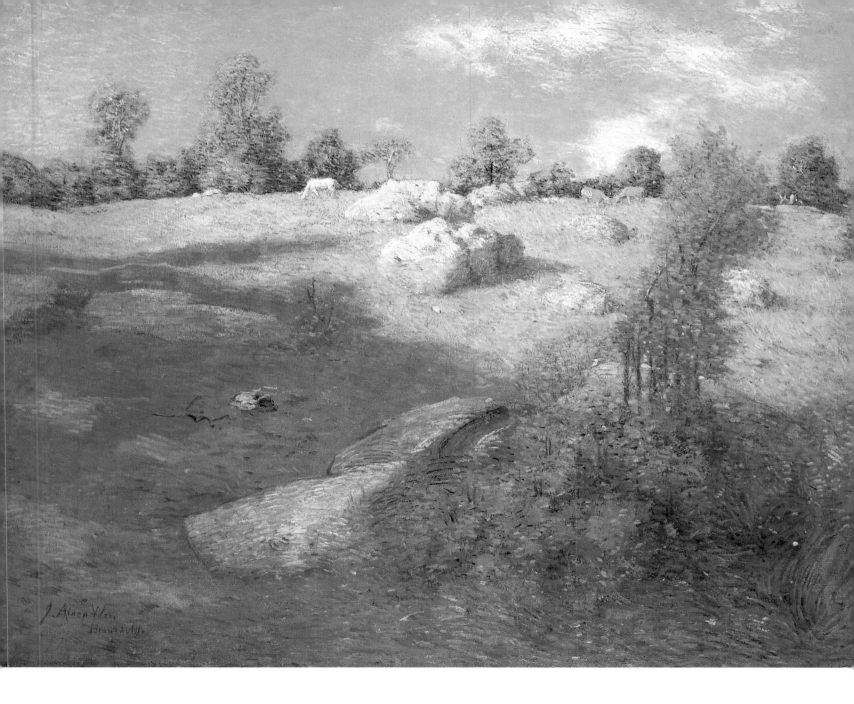

JAMES MCNEILL WHISTLER

1834–1903

Valparaiso Harbor

1866, oil
76.6 x 51.1 cm
Smithsonian
American Art
Museum, Gift of
John Gellatly

Whistler's poetic and mysterious images make it easy to forget that he was a student at the United States Military Academy at West Point, though he did not graduate. One of a group of expatriate American artists, the irascible artist passed his adult life in Paris and London, where he rebelled against established artistic conventions such as the telling of a story in a visually realistic style.

Valparaiso Harbor makes no reference to the actual events that caused Whistler to sail for Chile in 1866—the Chilean war of independence from Spain. Instead, the picture, one of several Whistler made of the Chilean harbor, borders on abstraction. The olive-green pier, green-blue water, and brown hills are assembled like pieces of a puzzle. Whistler guides our eye into the distance with the receding diagonal edge of the jetty, a use of skewed perspective inspired by Japanese woodblock prints. Rather than carefully depicting the boats and figures who stroll by the water, he creates hazy atmospheric effects that transform all into shadowy apparitions.

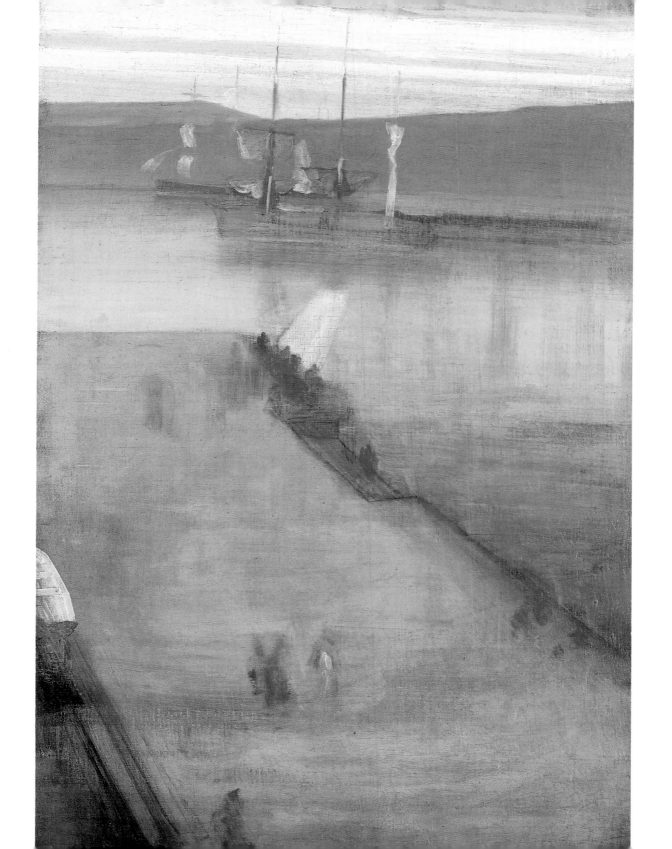

GUY WIGGINS

1883–1962

Columbus Circle, Winter

1911, oil

85.1 x 102.1 cm

Smithsonian
American Art
Museum, Gift of
William T. Evans

Connecticut artist Guy Wiggins studied in New York City, and it was there that he captured a snowstorm in Columbus Circle, at the edge of Central Park. This dramatic aerial view depicts the busy thoroughfare, full of activity even during a blizzard. Streets fade into the distance on either side of a triangular block of buildings while horse-drawn milk trucks and horseless carriages make their way around the monumental sculpture of Columbus. This is what the "New World" has become—New York, the rapidly growing urban hub of the United States. The artist included cars, a bus, and a smokestack expelling its waste into the flake-filled air, yet he uses his impressionistic style to mitigate modernity's darker side and soften the composition. He also adds excitement to the canvas by combining brushwork with oil paint smeared with the flat side of a palette knife.

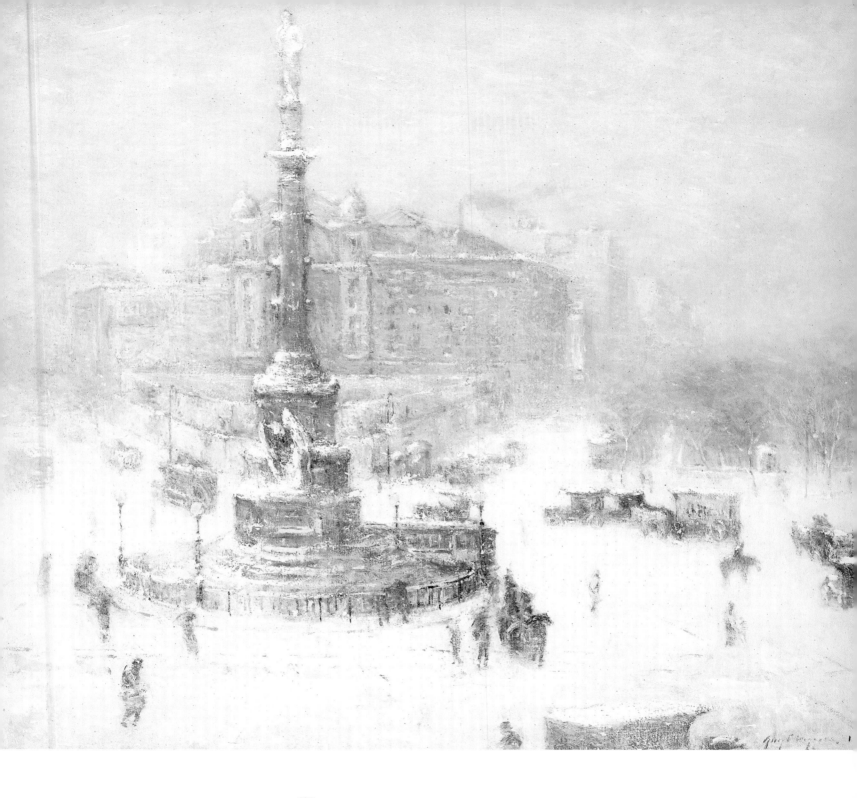

Index of Titles